Song of a
Dew Drop

Song of a Dew Drop

Dew Drop

Sudarsan Prasad

PARTRIDGE
A Penguin Random House Company

To order additional copies of this book, contact
Partridge India
000 800 10062 62
orders.india@partridgepublishing.com

www.partridgepublishing.com/india

CONTENTS

DEDICATION

This work is dedicated to the Goddess of Grace and Infinite power, Goddess SriDurga and Her son, the Lord of wisdom, SriGanesha!

My great teachers who taught me through their profound works, and enchanted me with the magic of the written and the spoken word!

My family: Chitra, Deepu, Nirmala, Raju.

Preface

Everyone is a poet at heart; some are more adept at expressing its sentiments. This author has tried to express the beauty of a tender thought in the language of the heart. Oceans and races can separate countries but the language of the heart and the colour of love-like blood- is universal. So is poetry!

During his scientific career spanning several decades, he had the good fortune to travel across continents and get to know people, their dreams, hopes, aspirations, thoughts and love of values which we call human. Everyone craves for love, dreams of the perfect love, and perhaps does not realize its value when one finds it. The result is a sense of void and loss, alienation from the main stream of society which adds to the pain of existence. Art and music has expressed this pang and sorrow in so many ways and in a feeble way, this author also has tried to do so in the following pages.

Given the pressures of living in a go-getting world with 'dog eat dog' mentality being the norm of the times, it is still possible to awaken and tap the basic goodness in every human. He believes in the lovable human and that faith is reflected in the poems. This author loves nature and children and has always struggled to think like them. This has been a big motivation to pen many of his poems. Like the glorious Sun and smiling children, hope this anthology will provide a 'brief sunshine' for the readers at a convenient hour. Thank you for your patience!

<div align="right">

Sudarsan Prasad
Pune, India October 8,2015

</div>

Commentary on the poet's work by fellow published poets

Nishu Mathur, India

"Sudarsan Damodar Prasad's poetry is captivating. Rich with metaphors and delightful images, his poems inspire one to be a better person. His work encourages his readers to seek what is positive and beautiful in life, in the outside world and within. Spiritually uplifting, philosophical, mystical yet rooted in the soil of the earth. One feels happier and alive reading his work. He is, as he is fondly called, a 'doctor of the soul'."

Marcia Schechinger, USA

"With grace, honour, love, inspiration and wisdom; I have had the privilege to become not only a friend, but also an admirer of the great works of Sudarsan Damodar Prasad. This book should change your life, as his writings have mine!"

Oba Dowell, Nigeria

"Reading Sudarsan, one marvels at the manner in which words simple in form weave together meaning that stretches to an inner spot as delicate as the soul. The power in Sudarsan's poetry is the flexibility of profound symbols they carry; flexible and profound in the sense that the depth of meaning in his symbols are immeasurable."

Nancy Crossland, USA

"The poet touches the reader in a sensitive, spiritual manner. He focuses on humanity, nature, and reality. Though in subtle undertones, his expression is so believable and relatable to all no matter their faith or position in life. Often his writings have a message that is powerful leaving the reader to ponder his words. Never to disappoint, I have found his poetry inspiring, meaningful, and always a pleasure to read. His book would be a welcome addition to any collection. A talented, gifted writer, Sudarsan gives his heart and soul to writing."

Christine Shaw, UK

"Dr Sudarsan is a gentle, modest man. A prolific writer of poetry, written in a soulful, romantic, classical style. He covers a wide variety of topics. Clearly evident in his work is his great love of nature, as is his love for children and humanity in general. As he says himself, he is one who eternally meditates on love and hoping to reach its fountainhead. I find his poetry inspiring. He has the ability to raise the spirits of those who read his work. I eagerly look forward to his first anthology, Song of a Dew Drop."

Acknowledgement

The author wants to put on record his immense debt to Mr. Jeff Humphrey who operates VoicesNet.com, Columbus, USA and his wonderful crew who helped him to grow as a poet. I also want to thank fellow poets and friends who frequent that favourite haven of poets(who are too numerous to be listed here)and encouraged me with their invaluable comments and suggestions, their motivating appreciation. I also express my indebtedness to Nishu, Oba, Marcia, Nancy and Christian for allowing me to publish an appreciation of my works, to be included in this anthology.

Finally, I would like to express my profound thanks to my beloved wife Chitra whose infinite patience in proof reading and whose constant encouragement helped me to finally launch this venture.

INSPIRATIONAL POEMS

"Those who have eyes will see! Those who have the inner eye will have insight! Those who are born blind will grope and fall, and instead of seeking refuge and solace, will curse the darkness, inside and outside!"

SONG OF A DEW DROP (1)

A dew drop on a tiny leaf,
Danced for a while
With the wind;
Not afraid of
A fall.

Ignoring the bright sun above,
Whose face will grow
Fiercer by the hour,
It danced and danced,
While the song
Of the breeze,
And the hum of the bees,
Lasted awhile.

"Let me have a whale of a time,
Dancing and swaying,
Before I drop down,
Into the huge gorge below,
Or vanish into thin air,
To join the angels,
Riding the clouds".

ONE STEP AT A TIME (2)

At times I would love to
Look at the past,
When there was much to know,
And I learned the charm
And magic of
One step at a time.
Then the floods arrived,
And I was left to
Live on a tree perch,
With only cuckoos
For company.

Now I begin the slow wait,
Till the floods recede;
So that I can walk on
Mother earth alone;
Learning again,
The charm and magic of
One step at a time.

THE PEN FOR THE SWORD! (3)

The hand that wields the pen
Has to abandon,
The pen
For the sword.

It is the need
Of the hour-so damned:
Evil has raised
Its ugly head-
With eyes,
Hungry and old.

No one is bothered;
Dire straits
Hard battles
Lie ahead.

Do you ever regret it?
Pen for the sword,
Held in hand.
Life's every hour
Has a plan carved
By destiny's sculptor.
So be it!
The hour of battle
Has arrived.

LIVING FOR OTHERS (4)

Living for others
Loving others
Ignoring gain
Ignoring pain;
Inflicted by an
Unforgiving man.

Shine along with the Sun
As sunshine
In others' lives;
Leave a trail of smiles
For others;
With nectar of hope
Dripping from a benevolent
And munificent heaven.

That is what it means,
To be born
A human,
With a particle of the divine;
Shining like stardust,
Away from the glare
Of limelight,
When I enter the arena
Of life and its vain shows.

THE TREASURES OF THE MIND (5)

If the mind has all the treasures
Buried in itself,
Why should I dig deep
For the elusive gold?

Why should I pan
The riverbed,
Sieve every grain of sand,
Particle by particle,
For the elusive nugget of gold?

Gigantic earth movers!
Enormous pounding hammers!
Huge robotic arms
Moving clay and earth,
Flooding the coarse stones
With stale human sweat,
Drop by drop
And drip by drip,
All these make an impressive scenario.

At the end of it all,
The diamonds are hiding somewhere else,
For sure!
The coarse ordinary stones are gleeful,
"We are here for you,
As free as ever!".

If only I had laboured
A little more,
Earnestly and honestly,
Peeled the plastic thin layers
Of the mind,
Ignorance and avarice
As the sticky twosome,
For the glue!

All the treasures of the mind
Would have been mine,
If only I had laboured,
A little, to peel.

DONATE BLOOD! (6)

Donate blood
And be blessed,
To get a blood-brother
Or blood-sister.

It is painless
It is harmless,
And also priceless!

Many times
It helps
To win back a sole bread-winner
From death's doorstep.

A new born can hope to see
Its mother alive;
The neighbours will come to know
That the stork
Has brought yet another
Bundle of joy for the mother!

An anxious father
Can hope to see his daughter
Alive and kicking
And chasing a butterfly;
That makes for two butterflies
On a run!

Grandpa will wake up
From his hospital bed,
To tell us the wonderful tales
Full of pep and fun,
And regale us once again!

All these and many more,
Accomplished with a few
Drops of blood,
Flowing from vein to vein
In the hour of dire need;
The greatest gift a man
Can bestow on his fellow man!

When suddenly smiles
Bloom in the dreadful,
Stifling, fearful
Atmosphere of the casualty,
Death has fled through
The back door,
Broken threads of life
Will be woven together again.

Donate Blood
And be blessed;
Get yourself renamed
As the blessing hand of God!

TWO THINGS CAN OUTGROW A MAN (7)

When I was a child,
I watched the shadow
Grow longer
By the hour,
When I showed
My back to the Sun.

I knew then that
Two things can outgrow
A man:
One is his shadow;
The other is his ego,
When he shows his
Back to the sun of knowledge.

Yet, the hold
Of 'ego',
The mighty 'I'
The invincible 'I'
Which held my mind,
In a dark prison,
Never loosened.

Then my merciful guru arrived.
He whispered,
As I was preparing
For a big fight
With the people of mighty 'egos',
To emerge the victor
In a shadow world.

LIFE - ITS MOMENTS

"Never seek the gain; seek only the glory of the moment. Like the quietly blooming flower, a new thought unfolds, sowing the seed of future good!"

IN THE NICK OF TIME (1)

In the nick of time,
A cruel pair of talons descends.
A piercing scream!
Suddenly the snow white
Turns blood-red!
Rip, tear and swallow.
Big chunks of warm blood-
Stained red meat,
Disappear in big gulps.
The falcon finishes his job
Of eating a meal:
A snow rabbit.
The blood drenched snow coat,
And the fleece
The only remnant.

Yet another time,
A shrill bird sounds
A warning note,
High pitched and loud!
The rabbit scurries and takes cover,
Hides in a hole,
Out of reach of the descending talons.

Empty talons
Cruel and hungry,
Go empty,
Hanging like black death!
Empty they remain
After a futile hunt!

In the nick of time,
The saviour gives a clear warning,
Talons go empty,
Peace of the air
And colour of the snow,
Both remain as they were,
Without the stain
Of a drop of blood!

I TEACH IN SILENCE (2)

I teach in silence.
I remain
Where silence is golden,
And faith is never shaken.
Thinking deep is as natural
As a cascading water-fall!

I am your simple soul
Caught in a mortal coil,
A cage of flesh and blood,
Forever bound
For ceaseless toil!

My lessons never lost
Even when dreams,
Fond hopes,
Are lost in sighs
And despair's dark moments,
At the end
Of a dark and dream-less night.

I am one with the dawn
When fresh thoughts dawn.
A new morn.
A new thought.
A new insight,
And the philosopher's delight.

I remain the ancient one,
Who teaches in silence.
Your intimate soul,
Inner guru and intimate friend.
I teach in silence!

GREETINGS, OH LADIES! (3)

From the cradle
To the grave,
You give solace
And shower grace
To infants,
Boys and men.

Doting mother,
Affectionate sister,
Loving wife
And life companion,
Adoring daughter,
Every father, a hero!

The first one to
Charm a boy
And make him climb
The long winding road
To adulthood,
Without letting him fall
Into the pit of sensuality.

More pure souled
Than men.
Never fought any wars
For crown or glory,
But nursed the wounded
With tender fingers
Of compassion!

Veritable Goddesses
Sent down by God,
To enable the child
To learn the first word:
'Love'
In a tongue, they only speak:
'The mother tongue'

A GOOD PAIR OF SHOES (4)

"To the one who has got a good pair of shoes, it is as if the whole of earth is carpeted with leather; likewise only a restrained mind brings happiness!"

'Hitopadesha -Ancient Indian philosophy'

Meet the resilient one
And an incredibly wise one,
Who has just a good pair of shoes
To call as his own!

He walks through sharp stones
And unpaved streets,
Thorns of the jungles,
Slippery mountain slopes,
Dirt paths and mud roads.
His only possession:
A good pair of shoes.
His feet unhurt and not stained,
His joy unalloyed
As he plods through the journey of life.

He walks though the sunset,
Without a tear being shed
For the loss of the day and its glory!
His sigh never escapes
A pair of tightly shut lips,
And never mingles
With the last whispers
Of a dying night!

He is firm as a rock;
As majestic as a messiah
Who guides the herd,
To the safe havens
Of the mountain caves,
And he stands guard at their mouths
With his staff;
His shoes still on!

He is the ancient one!
Yet, his picture never gets painted
On temple roofs
Or church walls!
You never meet him
On the pages of
Scriptures or sacred lore!

He is the resilient one:
With only a pair of shoes
To call as his own!
Is he none other than the mind-
Clothed in resilience?

AS IS YOUR SIGHT (5)

You see a beautiful flower,
The bee sees a coloured heaven
Oozing nectar and bliss.
You see an ugly mother,
With buck teeth
And plain face.
The infant sees:
A pot of life- giving elixir
Called mother's milk.

You see an arch of rain drops,
Refractions and reflections,
The child sees the rainbow
And chases the pot of gold,
At the end of it.

You see that trees have no eyes;
Yet, in them bloom flowers:
A treat to the eyes.

Philosopher and the poet,
Both see and hear
The same sight and sounds.
Their insights are never
The same!
As is your sight,
So is your insight!
Something to ponder
And wonder.

THE LURKING SPIRIT (6)

A deaf, mute and blind child
Knew how to smile,
Right from the cradle.
Cries of the grief-ridden mother,
Laughter of her
Gleeful enemy,
And the sounds of moving wheels,
The colours of the spring,
It knew not;
Yet it chose to smile
Its perpetual smile.

If spirit can see
Without the eye,
Can hear without
The ear,
And speak
Without the word,
Then I am seeing the spirit:
Blissful and cheerful
Wrapped in a package of tender
Skin, bones,
Flesh and blood,
Smiling its perpetual smile.

I am no holy man.
Somewhere in my inner corner,
There is a lurking spirit
Telling me to look for it, the spirit-
Smiling its perpetual smile.

WHAT I BELIEVE (7)

I believed in God!
He believed in:
My simplicity,
My honesty,
My industry,
And my faith
In him.

Every thought
Rose majestically
From him,
Before deciding to
Descend to earth,
To wipe many
A tear drop,
For the ailing
And the wailing.

I grabbed and held
A mirror:
A simple mirror
Of my mind
To the divine descent.
Found myself,
An inventor and originator-
In the flood light of fame.

The shouts, screams,
Blinking flash lights,
Whirring Cameras,
Did not appeal to me
One bit!
What I did was just
To hold a simple mirror
To the shining light,
And darkness made a quick exit
From lives and minds.

I do believe in
Light and its message.
Wipe a tear,
And see the darkness
Flee in fear!
I believe in God,
And he believes in me!

MOMENT'S GLORY (8)

Cherish not the moment's gain,
But seek its glory.
One more drop of nectar
Falls in the lap of the meadows,
Where the golden fleeced sheep
Huddle together,
Preparing for the night.

One more drop of ink flows
Out of the poet's quill,
Spreading the carpet of welcome
For the golden-tongued Goddess,
And I fumble with my old hands
To light a small lamp;
For, soon it will be night,
And the curtain of darkness
Will fall, surely will!

BEETHOVEN'S 9Th SYMPHONY (9)

Heard melodies sweeten with time;
Unheard melodies make time
Itself stop in its tracks.

Beethoven's 9th was composed
When he was stone deaf.
In silence
In desperation
In the solace of the soul
And the shadow of grief
He began his work,
Monumental, phenomenal,
And ethereal!

Unaware of the dawn,
Also the approach of the curtain
Of darkness called night,
Falling like a soft whisper
Uttered by the dying lover,
He sat absorbed,
Like an earthly God
Meditating on
What lies beyond earth and its horizon!

He set free the pure pristine notes:
Trapped in agony,
Of the prison
Of yellowed pages,
Of bars and lines,
Tones and half tones,
Bound by a dog eared
And time licked note book!
"Off you go, hasten to listen
To the music of the heavenly spheres,
And the divine minstrels!"

His mission:
To peel the last veil
Of the soul,
And lay it threadbare
Till only the music is left
As the innate core:
The origin of the primal sound
Unstruck and unheard,
Except by the very blessed!

Cease not, oh, divine sounds!
Sometimes flowing like
A serene stream,
Sometimes gushing forth
Like a frothy fountain!
At times cascading
Like the majestic water falls,
Intending to break the hard unyielding rocks
Lying in its paths,
Before twisting and swirling
To join the rapids.

Yet another time,
It pines like the old
Shepherd and his torn reed flute:
"Please, for one more time!
Make me hum
The song of the happy meadows,
Where contented herds lie huddled
Like the spring flowers
In its prime!"

Music my saviour!
Beethoven -the Baptist,
My soul receives the first sprinkle
Of the holiest water,
To take me to the holiest
Of the gates of the musical heavens!

TWO DEAD BUTTERFLIES * (10)

*This is a homage and tribute to the memory of two beautiful
butterflies: One Indian girl(14 years, New Delhi) and One American
child(8 Years, US) who were caught by destiny's fly-catcher. May their
souls rest in peace!*

Two buds
Not allowed
To bloom and smile;
Usher in the fresh smile
Of an enchanting dawn.

Destiny has a plan
Unknown to man,
Cruel and sinister;
Wraps us in despair
In a shudder,
And a fear
Of the unknown.

Two butterflies:
They soared
Heaven wards,
Not knowing, seeing,
The flycatcher
Meditating, on
The barbed wire fence.

All eyes on the wings
Of velvet with ornate eyes;
Body of a fairy!
A sudden swish:
A cruel and cunning swoop,
As the torn wings
Flew with the winds,
And fell lifeless
On an ugly thorn bush.

Why the fly catcher
Is born?
Perhaps, to tear the poet's dream,
Spreading on parchment paper,
And becomes his nemesis,
As he dies a thousand deaths
Watching butterflies getting torn-
To shreds -to see a fairy's body
Gulped down by cruel beaks,
Curved and crooked.

LOVE YOU SUMAN (11)

Dedicated to Suman's 6'th Birth Day. Suman is a girl's name, meaning flower. Suraj means Sun, is a boy's name. This poem is inspired by the divine love between a twenty seven years old young man and a little angel 6 years old. The cruel hand of destiny strikes on her 6'th birthday and the divine lovers end up in the grave yard. The story is real, but the names have been changed to protect their identity!

A bud so tiny and dreamy,
With a drop of nectar,
Adorning the sweet corner
Of a tender pair of lips.

Whisper is so sweet, then
What to speak of smiles?
Love's sojourn began yesterday,
The end of the journey
Is nowhere in sight.

Embrace so warm and cuddly,
The quiver of her little heart,
Like the terrified pigeon,
Held in a pair of hands
Nevertheless, all loving.

When love's shafts strike,
The flutter of the heart is
Like the waking bird,
Who has shaken off
Ennui and an errant rain drop.

The April blooms fade away,
Like the distant echo
Of a bird call;
But spring is here to stay forever,
When you smile - the smile of bliss-
And enchantment.

The day you were born,
Is the day God forgot
To frown at the earthlings;
For, the dazzle of your smile
Drove away the denizens of darkness;
And mother earth's ecstasy
Quickened the water falls,
And silver fish leaped in the air,
Happy in their fall,
Happy to embrace the mother.

May you never grow out of innocence,
May your birthday be the longest,
And may you live forever
In every heart, full of love,
As the finest flower: 'Suman'
With your Sun-God: 'Suraj'
Spreading bliss and sunshine.

A NEW DAY, A NEW HOPE (12)

Oh, princess Dawn!
Why are you, ever so smiling;
Inspiringly alluring?
Ageless, fresh and charming!

A new day, a new hope:
Much renewed hope
To make it happen:
A new path to hew
In a dense jungle;
To find a way out
Of the deep and clueless woods.

I stop at nothing
Save, my dream mission;
Far away, from the maddening crowd,
Intent on crying:
"Stop! danger and death ahead!"

Every one breathes;
Eats and sleeps;
It is better to have lived
For one intense moment
Of a life time,
With a fond hope:
That you are the chosen one
To accomplish the mission,
Rather than living as a drone!

ROWER OF THE BOAT! (13)

Rower of the boat,
What you see yonder
Is not a shark-fin,
But a Dolphin!

Leaping joyously
Greeting
Playing
With merry leaps
To touch the sky
Come, what may!

Rower of the boat!
Paddle strokes
Gentle and graceful,
Do not shake
The boat,
And its sole traveller.

The shore is near;
No shark is near.
It is one last glide
To the promised land

God's own land:
Where the breakers cheer
Above the roar
Of a fierce wind!

THE TREE OF LIFE! (14)

The tree of life
The tree of poetry
Everlasting kinship
Ever growing friendship!

Smiling faces
For both;
Human and enduring faces:
Alluring and enduring.
Charm of the soul
And the spoken word,
Colours both.

Civilizations and armies march on!
Their glories are gone,
And stolen by the buffeting
Winds of change.
Fierce and merciless,
Ceaseless winds.
Poetry and the tree
Both survive and thrive.

Eternal trees:
The tree of life
The tree of poetry.
Flowers- finest flowers-
Of humanity,
Its adornment;
Its smiling faces,
And its pride and purpose.

A NEW YEAR'S WISH (15)

Desires, fears, despairs,
Leftovers from the previous years!
Include dreams,
And the circle has come full.
Add to these vain hopes,
It remains life's
Tale for months and years,
Also, for the new year in birth pangs.

I want to flutter like a free bird;
More like a humming bird,
Hanging like a chopper
Whirring its rotor,
Its pointed beak
Arched and crooked,
But seeing straight,
Only flowers and flowers.

You fool the humming bird,
With plastic sachets looking weird,
Made to look like a flower bowl,
Filled with sugar water, coloured*
To look like honey.
And the foolish birds,
Drink it up all,
Drawing tourists,
Filling others' coffers!

Oh, foolish mind!
Water, coloured and sugared-
Is not honey,
Knowing it is good,
Real good!
Instead, a drop of honey oozed,
Will do for the year!

*Actually seen that happening in a TV Channel. What humbug in
the name of tourism! What a way to treat the divine messengers
(Humming birds) from the celestial regions!

I WANT TO LOVE, I WANT TO LIVE! (16)

I want to love,
Therefore
I want to live!
One wish to live for,
One wish to die for!

I want to be
The mother of an orphan.
I want to be
The father of a destitute.

I want to be
The soft touch
Of compassion,
And be the undertaker
For the burial
Of depression.

See me in the wild flowers
Which adorn,
The grave of the warrior:
Martyr unknown.

See me in the first lily
Whose glory,
Will shame the royal robe
Of king Solomon.

I am one with love.
I am one with life.
Embrace me
In your hour of need.
I will be the sweet whisper
Of solace,
With umpteen faces,
And one great heart.

PEBBLES AND STONES (17)

Pebbles and stones,
Adorn the pavement.
They are never precious;
At best semi-precious.

Diamond is not a stone:
A mere shining stone!
It has the pride of place,
On a crown.

It needs a jeweller
To value one as precious,
And the other as worthless!

It takes a poet-philosopher
To tell you,
The folly of both!

AT THE MOUNTAIN TOP (18)

It is lonesome
At the mountain top.
My sheep are huddled
Together and asleep.
The herd makes no bleating
To attract the wolves,
The mountain lion,
Or the sly black panther.

My heavy eyelids
Are battling sleep.
I cannot sleep,
For the night is long;
The meek and humble
Are easy meat,
For the prowlers
Of the moonless night!

I want to see another dawn,
Without the stain
Of blood left
On a cold stone,
And the torn entrails
Of a slain goat,
Hanging on the wayside bush.

Guard I must
Till I drop dead;
The skyscrapers-
Another name for lonely mountain tops,
The innocent and the pure souled:
The meaty lambs,
Hoping to survive,
Yet another day
Of the city jungle!

THE METAMORPHOSIS (19)

Another wave has receded,
After the floods.
The banks made fertile;
Only needs the tiller's sweat,
And the ploughs
Squeaking mirthful laughter,
As it sees the seeds
Filling the furrowed paths.

Soon the seeds will swell up.
Burst and decay,
To become one with
The mud and mire,
But not before the tiny sprouts
Show up shyly,
Then learn to hold
A tiny dew drop,
Which will glisten-
In the sun,
And become its sap:
The colourless blood.

Where did death vanish?
When did life reappear?
Who lost to whom?
And who is the reigning king?

WISE INDEED IS THE ONE (20)

"Wise Indeed is the one who compared the human soul to a free bird"
Indian proverb

Wise Indeed is the one,
Who compared
The human soul
To a free bird.

Happy on a cruise
With grace
And poise;
Never afraid of
A fall into the
Valley of cactus,
And thorny shrubs.

Never hoards
Grains and gems,
Never craves
For the lost riches.

Never barters and sells,
And makes fences
Or territories
For the skies;
With the heavens
Beckoning with wide open arms.

Free bird!
Take me too,
On a flight, yonder!
In you, I find lasting happiness
Without the stain of a sin.

Wise Indeed is the one,
Who compared
The human soul
To a free bird.
Adore you, my inner guru!
Well said, wise teacher!

THE CHILD AS THE FATHER (21)

"The Child is the Father Of the Man"
Wordsworth

We come across greater men
Lesser Men
Meaner men
Magnanimous Men
Petty Men
Braver Men
Cowardly men.
All of them began,
Their life's journey
As a child.

Adorable and innocence personified.
Carved out by God's own hand,
Their first breath
Inspired
By God's word,
And his express command.
The child was so blessed:
'' The child indeed
Is the father of the man"

No blame attached
To God,
If his sacred word
Was thrown aside,
As the grown 'man'
Led and vanquished,
Laid waste, kingdoms
Mighty and deified,
And raped virgin innocence by the thousand,
While angels cried aloud.

Then the saviour arrived;
Led small armies
Of the determined,
To wield the sword.
To protect
The honour of the land,
And its virgin maidens.

They defeated
And vanquished
Mighty armada
With sheer will and grit,
Led by unlikely heroes:
Unsung and unheard.

All types of men:
Noble and feeble
All began their journey
As an innocent child;

"For Child indeed is the father of the man"
Apologies to William Wordsworth.

THE LAST ABORIGINAL (22)

The last aboriginal
Threw away his boomerang
In disgust!
No more tearful cries
And dreadful screams,
As metal sinks its hooks
Into flesh-quivering,
In the pain of torment.

"I will prey on only my dark deeds,
And the vile hunter,
Snuggling inside me
In a demon corner!
Will hound him out,
And will hang him
On the nearest Oak tree."

Only the fragrance of tender thought
Will strike all in my eye sight,
Like the Cupid's arrow,
But quite unlike it,
Will return like a boomerang,
Soaked in nectar drops,
Love's precious drops;
And never the drops
Of life blood.

The first aboriginal poet was born,
Never to be forgotten again.
Tennyson and Walt Whitman,
Emily Dickinson,
All his incarnations,
Wielding their mighty pens!

WELCOME VISITOR! (23)

Welcome visitor
The most sought after
From so far;
Messenger
Of love divine
Beyond yonder.

I see no quiver.
No cupid's flower-
Tipped arrow.
Only a smile:
An enchanting smile
To fill my interior.

May you stay forever
In my quarter,
So hovel- like and poor,
Where an earnest quill
Gropes for a word,
Which describes your
Love and its magic.
Messenger from so far,
Blessed and so pure.

DESIRE'S DISGRACE (24)

Desire embraced,
Values thrown overboard.
Passion's flames climbed,
Skywards.

Wayward mind,
Craved for drops
To quench a forest-fire.

Waiting for the cool touch
Of the caring beloved,
To end the groping
In the dark,
In the woods;
In the dark night,
Under the starless sky.

MIRTH AND SORROW (25)

A child and child
Hug each other,
In mirth and sorrow.
An adult hugs another
Only in happy times;
More often than not.

A miserable adult
Is a loner,
And cries only
On wind's shoulders,
Which whispers
Sweet nothings:
"Be not afraid!
Dark clouds are not forever;
I will wipe them clean,
And the pearl white clouds
Will smile,
Full of charm and cheer,
And adorn the skies."

An adult who hugs
In your darkest hours,
Has kinship with
The whispering winds:
He is the true child at heart,
No, he is indeed the child of God!

THE SHEPHERD'S GESTURE (26)

The shepherd's one gesture is
To get a move on;
Beyond yonder,
Lies the green pasture,
Carpeted with velvety green grass.
Silken to the touch,
Divine to the taste.
Why the herd
Has not heard,
Paid no heed
To his cry, anguished?
Why they love to remain famished;
Locked in horns
Of dilemma and wars,
As egos clashed,
Butted and shed bled?

This tale
Was true yesterday;
Today and the day after.
Pay no heed
To the shepherd,
And wander in the woods
Weary and famished,
Thinking about and blaming
An absent and truant
Good shepherd, their lord.

WHEN THE WORLD TESTS MY PATIENCE! (27)

When the world tests my patience,
My limits
For tolerance,
Of bad vibes and words;
You make your presence
Felt in my conscience.

An assurance.
A reassurance:
At the end of it,
Good lies in wait.
However twisted and curved,
And diabolic your ways may look -
And cloud my sphere
Of consciousness,
With its shades
Of grey and darkness.

There is still light
At the end of the tunnel;
And it is still daylight,
And not a barren dark night:
Dreamless and hopeless!

ONE DAY IN THE LIFE (28)

One day in the life
Of a simple bloke;
No great job
Came calling;
No rushing past
The milestones
Of the great.

Sunrise and sunset
Ignored him,
While shining in the courtyard
Of the illustrious,
Along with flashing cameras
And cheering- gushing anchors.

What did he do?
This ordinary bloke,
In an ordinary day.
Ask the birds
Ask the bees
Ask the butterflies
As they rise on
The wings, on happy airs:
"You, our provider
And our beloved messiah!"

YOUR BATTLES ARE NO LONGER YOURS (29)

When you fight for values,
Life giving principles
Against sharp practices,
Your wars are no longer yours.

"They are as much mine!"
Says the mighty Goddess:
The gold mine of virtues.

"My blessings
Will shield and form
Your fort and rampart;
Myself your sentinel,
And also your mighty general!"

"The heavens are not
Ruled by a woman of easy virtue!
But me, the supreme Goddess!
People who sell themselves
And the eternal values
Never will receive
My grace, not even an iota of it!"

"Your battles are no longer yours!
It is as much mine as yours;
Your enemies-
My old sworn enemies!".

A HEADY BIT OF BUNGEE JUMPING (30)

Oh, my monster pride!
How, you took me
On many a rough ride
Through life.

Through roads much travelled
Universally hated
Ugly, unpaved and crooked,
Yet, with the false promise
Of a golden, royal road ahead;
At the end
Of this journey, arduous and cursed!

Trails of blood
All around
Conquests of empires
Marked, in a wily mind!

Empires founded
On bloodshed,
Foundation stones laid
With skeletons, skulls
Leering, clenched- teeth filled closed mouths
Of frightful deaths.

Broken chariots
Axles and wheels
Torn royal insignia bearing flags
All left in the wake
Of a burning desire,
To found an empire-
Where the Sun never sets!

What does it matter
If I have blood
On my hands,
Smeared with the blood
Of ravished innocents,
Drying under a red-hot
Angry red-faced
Powerless Sun?

Still my face is unabashed.
No shade of even
A feeble cloud
Of remorse or guilt.
"My empire is built;
That is what matters!"

Time to take another plunge
Into the depths
Of depravity;
Driving away
The alien intruder
Called solace.
Away, so far away
From my territory.
"Let thy kingdom come!"

"Heady bit of bungee jumping
This monster pride
Leaves you hanging
Alone at the end of it!"

ATTITUDE (31)

Attitude,
In that you should have:
Gratitude
Fortitude
Servitude
Towards the Lord and his herd;
And your arrogance,
Will fly away like chaff,
From the grain.

You fall down
To embrace mother Earth's
Floral carpet;
And also the Goddess's feet
Ornate, chiselled,
Eternally at rest on it.

I MAY BE LYING IN THE GUTTER ... BUT (32)

Lie low
Lie below
The lowest rung
Of the common milieu.

Stars at night
Shed so faint
A light;
Don't they reflect
The splendour
Of my vault?
A chandelier so magnificent
Even the richest
Of the rich
Will faint in fright,
If they behold it.

Gutter snipe, I am all of that:
Does not have even
A decent shirt;
Coarse bread,
No butter to eat.
Still never does fret,
About any tasty treat.

Still I am hope
Incarnate;
My atoms and sinews
Share a common secret
Of the effulgent light,
With the most ancient
Shining light,
In the heavens above,
And on ruddy earth below.
Can darkness ever dare
To cross my path
Even, as an errant migrant?

"I may be lying in the gutter
But I'm looking up at the stars"

A MARVEL CALLED LOVE,
A MARVEL CALLED LIFE (33)

A marvel called love
Was born
Somewhere, called as a heaven.
Soon after,
A marvel called life
Took root in the womb
Called the mother.

Life severs its bond
With the womb;
And is born again,
As a smiling new born.

Love forges a new bond,
Between the womb and the heart;
A big heart
And a small heart.

A flame has lit another;
None is a loser.
Love's flame lights,
All hearts big and small.
Life's warmth lingers.

One is the just cause
Of another;
Chasing each other,
On the revolving wheel
Of life.
A giant wheel:
A huge merry go- round.
Anchored on Earth,
Touching the skies.

A marvel called love,
A marvel called life.
Thank you God,
For both!

BECAUSE YOU LIVED! (34)

Because you lived
Many, too lived.
Their dread
Of black death,
Changed and vanished.
They smiled
And everyone was blessed.

Many breathed
A sigh of relief;
Their worries melted;
Where a bleak future stared,
People now laughed,
Laughed aloud!

Where worry lines reigned
On faces depressed;
The spider of opportunity,
Weaved a dark web
Of gloom and despair.
Peace has finally arrived.
Solace has dawned.

You were born
As the last oasis
Before the sea of sand began.
Really lucky charm and a' good omen'.
For the tottering caravan:
Buffeted by sandstorms
Blinded and harassed,
Found a desert pilot in you,
Who knew the stars above
Like the lines of his palm.
Again, a lost caravan found
Their destination
All because, you lived.

You lived
And people loved.
You became the idol
Of love personified.
You radiated
So much love and solace,
That people forgot the need
For a second and absent God!

Because you lived,
People loved,
And everyone was blessed;
Heaven's flood gates opened.

WHEN ILLNESS STRIKES! (35)

When illness digs
Its teeth into mortal flesh,
You long for the ordinary day:
A pedestrian day,
Which is a heavenly day.

Evil genius at work
In people's minds,
And microbe factories,
As they hunt their prey
With stealth and craft.

Thank God,
Their kingdom has a short reign
And there is someone
Up there to release us from the pain,
So that we can watch another morn,
And be early,
To greet the rising Sun.

To begin another ordinary day:
Free from the clutches
Of illness.
Would not that be heavenly?

I REMAIN FIXED ON A THOUGHT (36)

I remain fixed
In the thought
Of a good deed.
A good act of love:
A little food and drink
Dropping from the heavens
Before a starving kid,
And becoming lasting
Smiles and hugs.

The caressing fingers
Become magical,
And will play on an invisible lute;
Even the heavenly minstrels
Will drop their lutes,
And pause to listen
To the divine notes
Of the heart's strings.

I remain fixed on a good deed,
As the butterfly would
On a delicate flower.

AN EVERYDAY TALE (37)

"Miracles do not prove the existence of God. On the other hand, the regularity of the everyday events does that"

Albert Einstein

The thorn bush
Has flowered;
Flowers velvety
And not prickly,
To the touch.

The Cuckoo never went
To school
To learn music;
Great musicians
Who have founded
Eminent schools
Of music,
Marvel at her
Scintillating performance.

Sand dunes
In arid deserts,
Also write beautiful
Tales of love,
As the wind weaves
So many magical patterns,
Whispering "love never lost".

Water- not a drop
To be found,
The waves, nevertheless
No less enchanting.

I do not call these
Miracles,
But ordinary affairs
In the life of men,
And God's very own nature.

ALL CARDS ARE MARKED (38)

Blind man
Lame man
Dumb man
Deaf man,
All carry their burden
Of sin.

If only they knew
And pondered on
The law and the fruition
Of deeds done,
With or without intention
To seek and gain.

The sin of passion
Tasting its forbidden
Fruits of pain;
Writhing in pain.

Wielding the sword,
Slashing with the hatchet
Left and right,
To rise to the throne,
Using corpses
As stepping stones,
To grab the crown.

All remembered
With remorse,
Guilt and tears.
The holy Buddha said
"Like the carriage
Will surely follow the horse;
Karma leads
In turn, to pleasure
And pain"

Know the irrevocable law:
"All Cards Are Marked
And All Fates Will Collide"
This is nothing
But the sole-truth.

WHY DO YOU WANT TO MAIM? (39)

Why do you want to maim
Your blood brother:
Another poor unknown brother?
Instead aim
For the skies.
You will have high flying birds
And noble souls,
Watching from the higher heavens,
For company and adulation.

Soar upwards,
On the wings of the high winds:
A smooth and silky glide
To freedom and beyond;
Till even the bright heavens
Are left far behind.

You reach bright points of light:
The cradle of stars,
Stars of all bright hues and colours,
Among wise-men
And great Gods,
And here, your journey ends!

THE STORM HAS BLOWN OVER (40)

The storm has blown over;
Calm has descended.
Now you brood
Over your error,
And your vile action.
Can you point
An accusing finger,
At anyone?

Desire is the fire,
And the offering is you;
And your vain hopes
Of an unbounded happiness.

Alas, it burns!
It singes and burns,
All the wings
Of the birds of hope;
And its flights
Of fancy and its fond descents,
To the valleys of charm and cheer.

No clear and limpid pools,
To quench your insatiable thirst.
No lotus leaves
To alight and float,
Swaying with a travelling
Wave of the ripple.

No lotus flower:
Honey drenched;
Nodding approval
To the glorious Sun's
Magnificent ascent!

Mercifully someone is around:
With a calm smile
And a healing touch.
Serene is her countenance.

Deeply knowing is her
Kind glances
As she traps and ties
Your eager face in the coils,
And tender fibrils
Of her fragrant wisps of hair.

You know now that love will not hide
Behind a curtain of the
Dark and dreary destiny;
Any longer,
But will be earnest
In declaring itself:
As the everlasting love
Of your new blessed life.
Your Goddess of love,
Has finally arrived!

The storm has blown over-
And calm has descended.

GO AWAY, YOU DIRTY BLUES! (41)

Go away, you dirty blues!
Never come again
Another day.
Take a cue
From the serene
Blue sky;
Happy even
After dark clouds,
Arrive, deface,
Shower and go away.

Blue is the sapphire
Blue is the vast ocean
Blue is the lovely lotus.
All pictures
Of happiness.
Why your 'blues'
Should have a melancholy face?

MORE FOR YOU (42)

Inspired by a wayside scene, in which a handicapped father is waging the battle of life-bravely. He lost both his legs in an accident-is confined to a wheel-chair; nevertheless is trying to eke out a living by selling vegetables on the pavement, helped by his little daughter, tiny son and a teen nephew. No self-pity, remorse, only firm determination written large on his face. I was returning from a chain of mega -stores called as 'MORE', whose motto is displayed everywhere 'More for you'. Lucky, that I had omitted vegetables from the shopping list and could help his cause by buying a few items.

"More for you!"

Hoarse whispers
Of the world and its stores;
Buy sell and barter,
Loot, plunder and gather;
Look for gains, sales, profits.
More for you, *"More"* for us,
"More" for themselves.

Here is one lone warrior
Of many hard battles,
Lives *"More"* for his offspring.
The fast moving wheels
Kick up dust storms,
And heap dust on the vegetables;
Make them stale and unattractive,
And evade the attention
Of the fast moving humans,
Ever eager for gains.

He gives *"More"*
To others,
Takes less from others,
No glamour-no sign boards.
No counters and computers.

I learned a valuable lesson
From this simple soul:
The bravest warriors
Take less from life,
Give *"More"* to others.

In twilight's fading light,
As the huge sign boards
Came to light and smiled,
I stepped into the brightly lit
Court yard of my home and groped
For a pen and some lines,
To tell about his glorious tale.

A COW GIRL POET (43)

"If wishes were horses, then we could ride them to your doorstep"
Ancient maxim.

But wishes are not horses
Passions are unruly horses;
Indeed, very unruly horses:
Unbridled,
Ill- bred,
Bolting from the ramshackle
Stable of restraint.

Hoofs bounding
Fast and furious.
Pounding and damning
A fear filled -
Shaking mother earth,
Trampling virgin blood;
Mixing it with clay,
To found an empire
Of deceit and desire.

Give me a 'cowgirl poet'
Who has seen it all;
Tamed them,
And tied them
To the wagon of life and hope.

Whip ready
And a lasso ever ready
To ride on and on.
Come treacherous mountain terrain
Or the sheer precipice
Overlooking-
The valley of fall,
And a sin stained soil.

Give me a cowgirl poet,
And I will never
Ask for more;
The company of a fair maiden
Or the charmed
Magic wand of fortune!

I LEFT MY EGO (44)

I left my ego,
In a thorn bush.
Off you go, without a blush!
You have got me many thorns
In my life.

You impaled my dreams,
My subtle thoughts,
So that I became the thorn
In many a soul's thoughts,
And their long suffering
Chunks of bleeding flesh!

Rest in peace,
As a butterfly would,
When crucified by enormous thorns!
And watch with sad sighs,
My kin savouring the nectarine bowl.

LONG IS THE NIGHT (45)

"Long is the night for the one who is awake; long is the mile to him who is tired"

Lord Buddha

Long is the night:
Dark and dream-less night.
Ceaseless are my thoughts;
As I prepare for the battle,
In the dead of the night.

A vociferous cricket
Is my companion,
And sounding my bugle;
Creatures of darkness
Are lurking in the folds
Of the dark night,
Hoping to defeat
Me in my first battle.

The shining diamonds
With their lustrous points
Of light;
Shining up and above,
Tell me about
The power of one pointed thought.

The stars, as
The world calls them,
Egg me on
To become one among them.

A star will be born
Then in the field of battle,
The Lord will send
A chariot of fire
With a charioteer:
He too, made of light.
To wage such a battle!

Long is the night,
As I prepare for
The inevitable battle!

LOVE POEMS

"The first one to love never wrote poetry, perhaps; but the first verse of love was written on the walls of his/ her heart"

LOVE'S MOTTO (1)

Love's motto:
Not to lead,
Not to follow,
But every step,
Step by step,
Dance through life,
With a song in the heart.

The melody is ever fresh,
The harmony will put
The music of the spheres,
Heavenly spheres
Curving through the infinite,
Even to droop their heads
In shame and wonder.

Love never takes!
Seeks nothing,
Except the smile
And enchantment
To last forever,
Like this exquisite melody.

ODE TO A DROP OF GOLDEN SUN! (2)

This verse is dedicated to dear friend Marcia on the eve of her birthday
(NOV 8'th)

Golden hearted one,
Golden haired one.
A ray of pure sunshine:
Lustrous golden sunshine!

When I see the sun,
It does beckon,
Me to the celestial region,
Where you underwent
The baptism by fire,
And then sent back to an earthly plane
As the golden –haired one:
The golden hearted fairy God- mother!

Adoring daughter,
Doting grandmother,
Apple of the eye
Of one's own mother,
Ailing mother's guardian angel,
All these roles
Are your garbs
And ornaments.
Oh, you, the blessed one!

May you cast your magical spell:
Through poems and the web
Of enchanting thoughts.

The world of ideas
Will shrink their horizons,
And the ever widening circles
Of friends and admirers,
Will sing in unison and in chorus:
"Happy birthday! a drop
Of gold sunshine,
May you fall on all our souls
For evermore;
Happily, for evermore!"

I LOVE MY NEIGHBOUR (3)

I love my neighbour:
His smile is clothed
In innocence,
And made of sincerity.

The flowers of his garden,
And his children
Smile more enchantingly,
When I enter his home.

He is the one whom,
God has chosen
To reflect his
Benign and merciful glance!

What a mirror!
A true mirror,
Untarnished by
The smoke and dust
Of the fast moving
Wheels of progress!

AFTER THE SUNSET! (4)

After the sunset
The day-light may be lost,
But the day is not lost.
For, in twilight
Blooms:
Love's most intimate
Soulful expressions.

Night is young.
Hopes are forever young
For lovers and dreamers;
As they light candles
To behold,
Their beloved
And love filled faces!

Old melodies
Never lose their charm.
A new melody
Of love rises
To kiss the clouds,
And bid adieu
To earth bound desires.

How sweet it is:
To imagine the curtain
Of the night,
Laced with the golden
Aura of the candle light!

For every melody,
That is sung
As a duet,
Another is waiting
To be born,
In the womb
Of this blessed night!

After the sunset
Nothing is lost,
For lovers
Young and old,
Bathed in love's light.

I LOVED YOU (5)

I loved you
I became love incarnate;
For, when hatred tried to trespass,
My flower fences
With no sharp thorns,
Welcomed her scowling faces,
With charming smiles!

She was at a loss for words.
Equally at a loss
To fashion scythes,
To cut through my fences.
She admitted defeat,
And made a quick exit.

Even though every poet
And philosopher and thinker,
Try to explore and locate
Such a country:
Free from hate and strife;
They have to become love incarnate,
To seek thy kingdom:
Where flower fences
And their smiles,
Guard its territories.

LOVE IS NOT BLIND! (6)

Love is not blind.
Love sees,
Sows seeds
Of blessedness
All around.

Showers
Of blessedness
On arid lands,
Once barren lands-
Now bearing rich crops.

Scores of deserts
Shyly swaying their
Blessed floral crowns;
Believing in miracles.

Love the doer
Love the redeemer
Love the dreamer
Love the altar;
No sacrificial lamb
Seen here,
Shedding a painful tear!

Love sowing seeds
Sprouting bliss,
Seeing only blessedness!
Love is not blind,
Seeing only its beloved!

Pure love indeed
Sees all around:
The universal love of God,
The one without a second!

LOVE THY NEIGHBOR! (7)

Love thy neighbour!
Why should he ever
Remain a stranger?
Like a little puppy
Wagging his tail,
Charming one and all,
His toddler
Should crawl
To your doorstep,
To get a hug;
Fondle and cause a thrill.

Jesus's words
Spoken then,
Remain forever divine!
Lives forever;
Leads us to the shore-
Of everlasting life!

For, the one
Who has soaked
It in,
In his soul and being,
Becomes a being -divine
Fit for the heaven,
While rooted on earth.

Xmas message,
Loud and clear:
Is to love-
And overcome
Hatred's den and lair.

The enemy vanishes,
Like the fog in
The sunshine
Of the blessed morn:
A delightful Xmas morn!

THE DAY WHEN A PAIR OF BIRDS NESTED! (8)

The day when a pair of birds
Nested:
A pair of birds
Called *'Happiness'*
Nested deep within me,
In my mind
In my soul.
I called
It 'a festival day!'.

Merry Xmas
Diwali's fun filled days,
Joy filled festival days
Heralding
Light's triumph over darkness.

Gives us hopes
Of making it one day,
To that abode of
Unalloyed 'Happiness'.

When the eggshells
Crack and I am free;
Free at last to begin
The first attempt
To hop and jump.
Flap my wings
Clumsily at first;
Then surely and suddenly,
I am off without
Any fear of a fall!

AN ANCIENT BRIDGE CALLED LOVE (9)

An ancient bridge
Called love:
Never moth eaten,
Nor care worn.
Always witness
To the union
Of souls and hearts.

"How old are you?"
I ask him
"What is time?"
In turn, he asks me!
We both wink and smile.

Right under,
Quiet flows
The river of time,
Hiding a small giggle.

The bridge called love!
How many pairs
Of doleful eyes
Have adored you,
Worshipped you
As the forger
Of bonds,
Untouched by time,
And its ravages!
How many indeed?

WHAT BEGAN AS FRIENDSHIP! (10)

What began as friendship,
Grew into admiration.
Admiration soon donned
The colours of adulation.
Adulation gave birth
To sleepless nights;
Where shadows played
With light,
Till soul's light shone
Through
And showed the idol:
Long carved out,
Long worshipped in lonesome nights!

Love's first bloom
Smiled and wafted
Its fragrance;
To last a life-time.

TO MY BELOVED! (11)

When my head got
A pair of eyes,
I saw ugly sights
And pretty sights,
Dirty minds
And beautiful minds.

When my heart got
A pair of eyes,
I saw my beloved;
And saw my love's
Best reflections
In those lovely eyes.

Fawn eyes
With lashes,
Made of peacock feathers.
I saw the serene
Sea of love
Never overflowing its shore,
Me, swimming like
A silvery fish
On its sunlit surface.

When my heart got
A divine eye:
A sole majestic eye
I saw no enemy;
Everything was flooded
Bathed, submerged,
By the torrential down pour
Sent down by the heavens,
As the deluge of love!

My heart vanishes.
My eye vanishes.
Only the flood
Of love remains.
Wonder of all wonders:
My little self
Is gone forever!

WHEN YOU BEGIN TO LOVE A
TOTAL STRANGER! (12)

When you begin to love
A total stranger;
You begin to wonder:
Am I really in love?

What are the tell tale
Signs of being in love?
One face remains etched,
In a mind running
From one desire to
Another, like
A mad hatter.

Yet, one figure,
One form fences
My thoughts.
One desire- one ardent desire
Cries along
For fulfilment!

You begin to love a stranger;
Rather, the stranger
Has occupied the throne
Of your heart,
As a newly arrived princess,
Coming back after
A long exile,
In the wilderness
Of unseen, easily forgotten faces!

YOU AND ME (13)

You and me:
My Goddess and me.
One, a full bloomed flower,
Never wilting, and full of nectar.
The other, a shy bud
Longing to bloom;
You cast always a bewitching spell
Of an exquisite flower.

You: the ocean of music;
I am not yet
A full note,
Not even a half tone.

You the mighty forest,
Thick and luxuriant.
Me, a low creeper,
Looking for a tall and handsome Oak
To embrace and grow.

Why, I never ask?
When all thoughts are stilled,
I know and feel
The love,
Which knows no distinction
Between big and small,
The eternal
And the transient.

Love, boundless
Answers all queries,
Of a runaway mind
And its vagaries!
Am I not blessed then?
Forever, forever.
You and me,
An eternal couple!

WHEN LOVE WOKE ME UP! (14)

When love woke me up
With a gentle nudge;
A soft caress,
Whisper of a call
To wake up
And look up,
With the promise
Of more in the offing.

I sincerely wished
The Sun to go behind a cloud,
At least for a few moments,
To lie and laze,
And wonder about
The world without love.
The world without shine,
Hedged by gloom.

Thank God for one Sun
And many lovers;
So that brightness
Reigns in our lives,
Long after the sunset.

The long night
Is a delight
For those in love.
Love filled eyes:
Pointed stars
With ornate lashes.

Winking and blinking;
Brightening the sky
And the vast expanse
Of a love- lorn mind.

When love woke me up
I did not want to get up,
To over indulge
In a reverie
About lost time,
In an empire of love.

**Dedicated to all lovers: young and old and the teens beginning
to understand what love means!**

HUG YOU, LOVE YOU! (15)

Hug you,
Love you.
In you,
My hopes and dreams
Find their perfect perch.
My heart finds
Its perfect throbs.

Love incarnate!
Time stops still,
Like there is no
Tomorrow.
No thought of sorrow,
Ever dares to cast
A shadow;
Growing by the hour,
Hungry and lean,
Lengthening at sundown.

The mangroves are full
With flowers, brimming with bees.
The cool breeze is envious:
A sheer intruder,
To tread on like
An errant traveller
With clay feet,
Not knowing his whereabouts.

Moments are precious.
They are ever so priceless!
They enter into oblivion,
To reappear at an early spring's
Fond and enchanting smiles.
And time stops
Dead in its tracks,
For one more time.

SWEET KISSES NEVER SEAL
THE FATE OF LOVE! (16)

Sweet kisses
Never seal
The fate of love.
Loving hands
Love filled hearts
Lovely roses,
Changing hands,
Open broad avenues.
Royal roads:
Mind to mind
Soul to soul.

Sweet nothings
Whispered in still air
Makes the world unreal;
The lover's dream surreal.

Bliss and solace
As the everlasting
Truth to unfold:
The one and only
Existent reality.

CLOSER TO MY HEART, MY LOVE! (17)

Closer to my heart,
My love;
Closer to my love,
My soul;
Closer to my beloved,
My heart;
With a love filled smile.

Closer to my inner Eden;
Where time does not fly
But crawls
Under a spell,
In enchanted circles,
With love at
Its centre.

Closer to this
Charmed moment,
With the pen
On a wander spree,
To stop and pause
And wonder,
At the splendour
Of the inner Eden.

WIPE YOUR TEAR! OH SWEET SISTER! (18)

Wipe your tear
Oh sweet sister!
Have no fear;
Your brother is near!

Give me a bear hug,
As you girdle
Your arms around me.
Me, the one
With a winsome smile:
An all knowing smile,
Allaying all your fear,
And soothing your soul!

Remember my smile,
While we played
On the beach sands.
A mighty wave rose
From the dark depths
Of a sinister sea.

It grew and grew
Its dark demon face,
Till it broke
With a hideous roar,
To sink your lithe little frame;
And you ran like the devil
To seek high land,
And ended up climbing me,
With a fearful hug and a shiver
Down your spine;
Shaking like a tree
Hit by a typhoon!

Today, years later,
Once again,
Another rough wave
Is rising, shaping
To sink your boat!

Have no shudder,
I will allay your fear
And take you ashore;
My all knowing smile
Will do it all:
Perpetual and eternal!

LOVE IS BLIND (19)

Love is blind
To the lover's faults
And blemishes;
It is also blind,
To the cruel designs
Of an evil destiny,
Waiting behind the bushes
To strike, without warning.

Love stories end with
The death of a lover;
But it becomes immortal
When the poet's
Quill does a recall,
In a tranquil hour.

Love oozes
Like honey,
Slowly, from the interior
Of a tender
Flower -petal heart.

If all the oceans
Were to flow as ink;
All skies
Spread and laid
As parchment paper;
Still many love tales
Will remain unwritten,
On the face of mother Earth.

Love inspires;
Caresses and soaks up my soul's
Most intimate pool
Of tenderness.

The flowing lines
Describe the magic
And charm of love's fountain:
Never dry, even
In the worst
Summer of discontent.

A TENDER CARESS! (20)

A soft kiss
And a tender caress,
Built a nest
Among the clouds,
Atop a tall perch
Of a kindly tree.

Mornings spent in
The company
Of the golden Sun;
Twilight's golden aura,
Added to the warmth
And glow
Of the lovely couple.

One day a cruel destiny
Sent down
An evil plan,
And a huge forest fire
Raged, and burned
The nest and the kind tree
To ashes, along with the tall grass-
Growing envious,
To take a peep
Into the home of delight.

Marvel of marvels:
As I saw the blessed pair
Fly past my window sill,
I rubbed my eyes
In wonder and disbelief.
Phoenixes are real;
More real for the poet
And lover,
Than a fabled fairy tale.

LOVE BLOOMS (21)

Love blooms in pits of depravity,
Pits alien to sunshine,
Fragrances and smiles of flowers,
Greenery and velvety grass.
Yet, it yearns for sunshine,
And golden drops of the dawn.

Still, I believe in love changing faces,
Filling hearts and souls,
Obstinate as the poet's quill,
Held in famished hands;
Nevertheless cared for by the mother of lore.

This song is never sung,
But its melodies are ever heard
Above the din and bustle of life;
In the nests of the siblings
In the huts of the tribals
In the hearts of the lovers;
Devotees and the wanderers
The mendicants and the seekers;
And they find it,
Sooner than the next breath.

LOVE AND KISSES (22)

Love and kisses
Fluttering eye-lashes
First blushes
Divine serpents
Uncoiling and then binding,
Lovers' hearts
And souls,
In immortal coils.

Love's blushes
Outdo the autumn-forests,
On fire and in heat,
Waiting for the cool touch
Of winter's wet fingers.

As much, but a lot more
Would love and crave,
For the beloved's melting,
Dissolving and soothing
Moments of capture
In the serpent's blissful-coils!

FRIENDS ARE FOREVER! (23)

More than faces
And appearances,
Races and colours,
Minds and souls,
Thoughts and deeds
Build bridges-
Across continents;
The seven seas
Powerless, mute witnesses.

How lucky we are to be born,
Together, to celebrate
The festival of life,
With friends whom we have never seen;
But who still understood,
The language of love
Which flowed through their quills.

May your writings
Shoulder the burden
Of the heavily-laden,
May your writings
Help their hearts bloom,
Like the dew-drops,
Which fall in a silent-slow trickle,
Yet, reappear as the fragrant rose's
Blessed honey-drops.

HAPPY DAYS ARE HERE AGAIN! (24)

*Today -18 November is the birthday of my beloved friend and life
partner Chitra. I find my pen not flowing enough to greet her on her
birthday as she is a very unique, affectionate and deep personality
whose depth I cannot fathom, even though we have been married for
31 years*

Happy days are here again.
Sun never sets on this day!
Even if he does,
None ever will know it.
As the kids gather all around,
Munching on goodies
And creamy chocolates!
Showering you with wishes,
Spreading cheer and sunshine!

Another milestone,
Another day
Of bear hugs,
Wishes and whispers,
Affectionate pecks,
Another day to cherish
And desire and hold
To the bosom;
Another precious pearl,
To add to the treasure chest
Of happy memories.

As the evening of life
Is near and life's
Burdens fall like petals,
Of a flower with seed
Growing in its womb,
Soon it will be night,
And time for happy musings,
On a bed of happy thoughts,
With mother fairies,
And blessings,
For company!

Wish you many, many happy returns of the day!

THE LANGUAGE OF THE HEART! (25)

The language of the heart
The eloquence of the eyes
The throb of a heart
Brim -full of emotion
The flow of solace
All wrote together
An awesome script.

The only thing that was left:
The choice of the pair;
A pair of doves
A pair of lovers
A pair of birds
A pair of dolphins.

God's choices are infinite;
Infinite is his love!
So are his expressions:
Waves in an ocean of love.

TO A HUMMING BIRD (26)

*Inspired by a too frequent scene in my garden of a humming bird,
ignoring the beautiful roses and hanging on to a simple Hibiscus!*

A bloom of love
Beckoned a love bird:
A humming bird,
Seeking nectar
And love;
Ignorant of the divide
Which separates
The noble
From the humble.

What prompts
You to visit the Hibiscus,
Humble Hibiscus,
Among the Rose-princesses
And their ornate clothes?
Why you choose
To hang on to the humble Hibiscus,
As if it is
Your own dear life?
Your precious love-
And never lets it go?

I wish I knew the answer!
But deep within, I know:
Behind a plain honest face,
A nectar pot lies in wait,
For those who seek
Love's nectar,
Beyond guises and appearances!

YOU ARE IN LOVE! (27)

You retain
A tenderness:
Love filled eyes,
Total forgiveness
To the world -so vicious;
Its arch villains.

Children's smiles
Bright and happy flowers
Pearl white clouds
All roll down welcome carpets
For happy days,
Months and everlasting years.

Tender moments
Of togetherness.
Soul filled bliss,
Not soiled by
The tarnished breaths
Of old passions.

Love begets
Noble deeds
Blessed grateful tears;
Like the fragrance
Of flower baskets,
Carried by angelic bridesmaids,
In its wake!

Your life's happy songs,
And the fragrance
Of your virtues,
Arrive at people's doorsteps

Like milk,
While it is still dark,
And the Sun has not still shown
His effulgent face;
No, not yet!

Who will then frown
And arch their brows,
To hear sounds
Of mirthful laughter
Floating
In the air?
From a happy home:
So far,
Yet so near,
Early in the morning?

LOVE AND HATE (28)

*Written in disgust and anguish after the recent bloodbath in Mumbai,
followed by the carnage in Norway!*

Those who love,
Will found the paradise.
Will discover it,
Adore it.
Inner and growing lovelier
By the hour;
Also the perpetual shower
Of pure nectar
To go with it!

Those who hate
Will find the paradise lost,
Even before John Milton
Began his write!

Those who hate
Will crumble
And be ground to dust.
To be scattered
In a desert,
Loveless, arid, lonely
And desolate,
Without the foot print
Of the camel and the caravan.

When I see the blood
Of innocents,
Spilled, curdled
Like ugly botches
Turing an angry red,
Drying under a sad Sun;
I wonder why
Such hatred takes deep roots
Among the wise humans:
Who harbour love filled poets
And compassionate philosophers?

I am still groping in the dark
For an answer,
And I remember the old English wise-crack
"Truth, like milk
Arrives in the dark
And wise dogs do not bark!"

BEFORE THE DAY FADES OUT (29)

"Those who marry for love and not riches, have poorer days and richer nights"

French proverb

Before the day fades out,
Listen to the whispers
Of the night:
Young and voluptuous night!

Love blooms;
So do flowers
Of the flesh.
One has the fragrance
Of the divine;
Other has the smells
Of a sticky earth,
Moistened by the first drops
Of a brief shower!

Hot vapours
Of passion,
Like the circulating air,
Rises in the heat
Of the moment.

Passion flowers
Ignore the fruits
Of pain,
Which will grow
Someday, on your *'tree
Of life'* sooner or later,
After the flowers wilt
And fall down!

Instead a choice
Can exist:
To swim like a fairy tailed
Silky gold fish pair;
To sink in the cool
Waters of love:
Ocean of contentment
To greet the morning
With a bubble of joy,
On a sunlit surface,
All aglow with delight!

THE ANGEL HAS FLOWN! (30)

Composed in honour of the departed angel- Taruni Sachdev -gifted child artist

The angel has flown,
Back to her abode in heaven.
Her angelic smiles
Her tender expressions
Her big saucer like eyes
Her grace and her prowess
As a child actress,
All will remain in our hearts;
To haunt us
To enchant us
To sadden us,
Long after she has flown.

What a sad day!
A cruel joke
Played by a cruel destiny,
As she was peering over the pearl white clouds
Over- hanging the huge and awesome Himalayan ranges.
Laughing in mirth
And clapping her hands,
With childlike mirth.

Suddenly when death's sinister laugh echoed
On the snow white,
Ice clad mountain tops,
And ugly red blood
Painted and wrote
The black letters of a death warrant.
An angel was lost!

The curtain has fallen
On a bright and short career.
The spectators are mute and silent,
With hearts burdened with grief.
The fragrance of her memories,
Will waft in our stale lives.
Make us wonder,
About the reality of a drama called life:
Real or virtual?

I AM THE PRINCE CHARMING (31)

I am the prince charming
Without a crown.
Never will be crowned,
The lord and king
Of even an island nation!

I evoke the happy smiles,
Of toddlers and infants.
Left to fend for themselves
On unpaved roads;
While civilization is making
Huge sleeping quarters:
Tall enormous skyscrapers
Kissing the clouds.

Their mothers have dead eyes
Their fathers merge with the furrows,
And have the colours of burnt clay,
Overdone by a fierce
Unrelenting Sun.

The flower girl looks happily at me.
After a few coins change hands,
Her face is in full bloom:
Another exquisite flower
Blooming in a desolate street corner.

The stone crusher is thirsty,
As enormous steel jaws
Gleam in the sun;
"If I could get a drop
Of love from the prince charming,
My toil would be a lot easier".

I am the prince charming.
About to begin my toil
Of a long winding day;
And hope to reap a rich crop
Of charming and full blown smiles,
At sundown!

MY BELOVED, MY GODDESS! (32)

My beloved, my Goddess:
One charming princess
Of bliss.
Soft velvety touch of a caress;
Precious during hours
Of stress and duress.

Moments fly
Far and away.
They eventually return
To their haven,
To stay huddled
Under wraps,
Like the adored children.

Stay with me
In the valley of flowers,
Watching sunrise
And sunset.

Borrow a shade;
Sometimes a little shine.
Add to the hues and colours
Of the splendour
Called love!

I LONG FOR THAT LOOK (33)

I long for that look,
A love-filled look.
Why do you keep
Your beautiful eyes closed?

Oh! I forgot,
That you see
With your inner eye,
And reach with
Your expansive heart,
This limitless
And vast universe:
A drop of its
Life blood.
Its quiver:
Love's first fond whisper!

SPIRITUAL VEIN

"Deep within every human, there is a spiritual vein. It is of celestial origin and totally divine"

FREE LIKE A BIRD (1)

"Look at the birds, they do not sow or reap, they do not hoard! Best of all, they do not trade and barter and drift away from each other"
Inspired by the Holy Bible

My crown- head!
He is more majestic
Than a king wearing a crown.
God has given him a crown,
Which he wears even
In his sleep
Without any pain.

My weaver bird:
He does not weave
Any fabric of dreams,
Yet he does build
A dream nest,
Where there is no sunset,
For hopes and dreams.

My sweet quail:
Her lithe body
And her dream tail,
Begins her dance:
A swell dance!
Even the waltz,
"The Blue Danube"
Will not suffice!

I can go on and on,
Till I take a cue
From the squirrel
Scurrying hither –tither,
And stops to pray
While sharing a grain,
With these winged
Angels- birds!

Thanks for the sights
And sounds, oh, God!
Someday I will join
Them, like a true
And free soul!

WHEN A SHAFT OF LIGHT HIT MY SOUL! (2)

When a shaft of light
Hit my soul,
With a fist
So tender and mirthful,
I watched in amazement
At the thought:
There is something in me,
Made of pure light,
Which refuses to believe
In the reality of a body,
Which cast shadows
In the path of light!

I looked at its origin:
My beloved sun!
Smiling and cheering me on,
The symbol of a selfless mission,
To light up my interior,
And the cursed corner
Where the miserable lay huddled,
Fighting the bitter cold;
To catch every one
In the web of contentment!

The new year has just begun,
But the shaft of light
And its cavern of delight,
Which is its origin,
Will be seen by everyone,
Who knows that the Sun
Belongs to everyone,
Who looks at him with fond eyes.
Adore his shafts of light-
To remind us gently,
That all of us are made of light!

There is no hiding place
For grief and darkness,
On the face,
My beloved Sun!

WHEN A LOTUS BLOOMED! (3)

When the mud cracked
And a lotus bloomed,
I wondered;
Marvelled
At that beauty personified.

Why such fragrance;
Such a fragrance
Among stinking mire and mud?
Why divinity bloomed
In such sordid, cursed
Surroundings?

As sunlight peered
And poured,
Through my windows
With curtains drawn,
And blessed my quill,
I do not know all the answers.

We only admire and adore
Beauty, divine beauty!
We never worry about where its roots lay:
Slimy mud
Or stinking mire!

That is what, the light whispered
While sinking delightfully
In a sea of light,
Called my poor soul!

THE WHITE LILY HAD TO BEAR
BLOOD RED STAINS (4)

This is how an Indian Hindu Looks at the supreme sacrifice of Lord Jesus, suffering mortal pain on the cross, yet never cursing his tormentors, and pleading for mercy with the father, for the bigoted, ignorant oppressors

When the white lily
Had to bear blood red stains
Of fresh blood,
Spilled by oppressors
Of the kingdom of love,
Angels wept,
Mother nature wept
In torrents,
Threatening to deluge,
A tottering burden laden
Mother earth,
Groaning under the weight
Of oppressive sin!

Suddenly a flash of lightning
Descended,
The mountains lit up,
And there shone a frail form
Nailed to a mean cross;
Head looking up
To the heavens,
Pleading forgiveness
For his tormentors.

Bleeding in throes
Of agony,
But, yet in the bliss of communion
Of the son, father-
And the holy spirit,
Praying for release
From the clutches
Of the deadly sins,
And vicious evil mongers.

As the sheets of rain
Flowed down as rivulets,
Coloured with a tinge
Of the sacrificial blood,
Lepers were cured
Of their maladies,
The blind regained
Their sight,
Miracles happened
Gladdening the hearts
Of the long suffering humans.

The simple
And the faithful
Looked up;
Thanked the heavens.

The lilies will be washed
Free of all blood stains.
Humans, of all the cravings
Of the mortal flesh;
For, when the heavens
Burst and open up,
The mother earth
Will be washed clean too.

Then the waters of everlasting
Life will course
Through the brows
Of all rivers,
Quenching all thirsts;
All cravings drowned
Forever, forever!

GOOD SOULS AND GOOD SMILES! (5)

Good souls
Have good hearts,
And a good smile
Free from guile.

Smile, the mirror
Of a beautiful interior!
Kept clean
By ardour and prayer.

Love, the best mop
To keep my hovel
Clean and tidy.
I live with the hope:
That a stray ray
Of divinity
Will enter my soul
Some day.

I will know then, that
The king is at my gate
Bestowing riches:
An inheritance
From the heavens,
Never lost to thieves!

*Inspired by all the Messiahs of love: Jesus, Buddha and Krishna!
Incarnations of pristine pure love!*

GOD IS ALL AROUND ME! (6)

God is all around me!
He is peering through
The tree tops
Right at me,
With a winsome smile
Of the bright sunshine.

He is crawling along
With the caterpillar,
And flying away
As the beautiful butterfly,
Somewhere, some time.

He is holding a nut,
On a famished twig
Of the tree,
For the praying squirrel,
Right before my eyes,
Who prays with both hands,
For a windfall
In hard times:
His hole in the tree
Flooded by incessant rains,
And the babies whimper and squeak
For a little nut.

Why he has to make a special appearance
For me, who is nothing special,
So that I will believe
In his existence?
He is all around me,
For me to see,
If only I kept my eyes open;
Wide open!

SMALL, SMALL ACTS OF KINDNESS! (7)

Small, small acts
Of kindness;
Little, little grateful smiles.
Drop by drop
The hearts are filled
To the brim;
For the giver and taker:
Bliss and peace for one,
Delight and gratitude
For another.

Both form the hands of God:
The giver
And the taker!
The philosopher sees
And wonders:
The hand which gives,
And the hand which takes;
One is higher than the other?
Really? Not really!

THE GODDESS'S EYES (8)

The Goddess's eyes
Suddenly glowed:
Flames, golden tongued flames,
Burning bright without
Even a tinge of angry red,
Shot forth and cooled
A frenzied mind.
Loved and adored:
This rare sight
Of intense delight.

I summed up all the hopes
For the day
Yet to unfold,
And the night fall
Sure to follow,
Like a revolving wheel
Of time, obedient
To the designs of
A certain destiny.

Offered it all at her feet
With great reverence;
And bowed my head,
Surrendering all actions;
Their fruits,
To her sweet will.

Goddess's eyes:
Love filled;
Full of grace:
An infinite measure of peace
Beyond words and quills,
Kindles all the flames
Of love and kinship.

AUGUST CHRYSANTHEMUMS (9)

August Chrysanthemums,
Bloom.
Spread their unique charm;
No great fragrance,
No Rose or great beauty,
Only simple charm.
No wonder,
They are the favourite flowers,
Of the supreme Goddess:
Like her simple devotees!

GREAT PEOPLE SHINE FROM AFAR (10)

"Great people shine from afar, like the blue mountains"
Lord Buddha

Great people shine from afar,
Like the shining
Snow-clad, wind-kissed
Majestic blue mountains.

Touching the rim
Of horizons,
Pondering on the horizons
Of knowledge, finite and infinite,
And life beyond,
The visible horizons.

White cotton clouds:
Fluffy, light and light-hearted,
Whisper sweet nothings:
Love tales
From far-off lands.
Tales of conquests
Of great men over
Ordinary men in the grip of vices;
Their minds and hearts.

They never cast the shadows
Of grief and ennui or despair,
Rather they inspire people
To come out of shadows,
Stand in the path of light.

Travel through less-known
Mountains roads,
On the rough terrain,
To truth and everlasting
Summit of life's true delight.

I prefer the glow
Of the blue-mountains,
To the shine of a trillion stars,
As I come to rest
At the feet of this great,
Noble soul-mountain of strength,
Now shining from so near,
Within touching distance!

GOD: HIS JUSTICE (11)

Justice is blind;
None can blindfold
God- the supreme
Dispenser of Justice.

When you see the blind,
The deaf,
The mute,
The bind-deaf-mute,
You wonder:
How can the benevolent God
Be so cruel?

Then you see a bomb blast.
Limbs strewn all over;
Blood stained rag-dolls
Of dead humans!
Air foul
With the putrid smell
Of burnt flesh.
Hideous scenes
From hell;
Wails, moans,
Shudders and gasps.
Banshee like cries,
Death's laughter
And sinister dance.

You wonder:
How can God be so cruel?
How can it happen?
God liking the colour
Of innocent blood.

Then, you remember the Lord
And the wise Buddha:
"When Karma ripens,
The fool suffers grief!".
"None can escape
The consequences of evil action!"

Blind terror
Leads to the blind
Groping in the dark;
Not knowing sunset;
Not seeing sunrise;
The colours of autumn,
Or the splendour of spring.

Living in a world
Of sounds;
Cause, you brought
Misery, darkness
In others' lives,
Your Karma has ripened
And you taste the bitter fruit;
You have no choice!

Written after a terrorist strike in Mumbai City- another bloody event which makes you shudder and shout in angry outburst and lament the loss of innocent lives!

WHEN THERE IS A SHOWER OF BLESSINGS! (12)

"His bounteous gifts, his divine wisdom and wealth are given to his devotees as spontaneously as a ripe fruit drops from a loaded branch!"
RIGVEDA

When there is a shower
Of nectar,
Why should I take shelter
Indoors, in a secluded corner?

His fruits:
His priceless gifts;
Ripened in the Sun
Of wisdom,
Taste divine,
Every day, every time!

When gentle breeze blows
Why, I know not
That it is a merciful
Wind of change,
Making the branches sway,
Drop fruits by the dozen
And make the loaded branches lighter.

Their rustle, now
Like the murmur
Of a lover:
Eager and intense
Love filled whisper.

Their past burden
Is now my song
Of delight,
As eager and famished hands
Reach for me,
And my palm full of fruits!

When there is a shower
Of nectar,
Why should I take shelter
Indoors, in a secluded corner?

GOD WANTS TO PROVE A POINT! (13)

"Subtle is the Lord! But, he is never malicious!"
Albert Einstein

When God wants
To prove a point:
He does it in ways
Which baffle the intellect,
Bewilders the mind.
His ways are always:
Subtle and noble,
Never malicious!

Why a tender sprout
Should appear in
The crack
Of a hard rock?

Why the beautiful peacock
With a heavenly plume
Can only hop
To a tree top
While a tiny sparrow
Can fly over the wispy cotton clouds?

Why many great men of wisdom
Never saw the gate of a school
Yet, inspired many fertile
Schools of philosophy?

Why fame should come
To lift and elevate
An obscure scientist
Watching the sunset
Of his career,
When suddenly the lime light
Fell on him
And catapulted him*
To glory and fame?

Subtle is the Lord,
Always tending the herd:
The old shepherd,
He is never malicious!

*Inspired by the tales of many Nobel Laureates, whom fame ignored
during their active career span!*

AN EARNEST PRAYER! (14)

Burst my ego bubbles,
Rising out of the dirty
Pool of my mind!

Not a serene lake
Reflecting the glory
Of the surrounding mountains:
Its majestic peaks,
The valleys in full bloom,
Grooming themselves
For the festival of spring,
And its rituals of dance:
Exuberant fun and frolic.

Empty the lake of mud and mire.
The stinking mire
Called insatiable desire;
The light and floating film,
Called the hope for more;
The sinking mud
Sticky as ever,
Called desire's horrid end.

Rid me of my vices,
And their vice like grip;
As they surf my mind lake
With delight and gay abandon,
Like the spindly -legged water beetles
Riding the water waves
By the dozen,
And set the train of waves
Of passion in motion.

This is my last desire;
That the mind lake
Is fit to hold
A perfect and shiny mirror
To a new dawn's delight,
And at the end of a fruitful day,
Mirror the fading lights
Of a glorious sunset.

MY GODDESS - MY BELOVED! (15)

You smile once,
I am ecstatic!
You look once:
A look moistened
With deep love.

I am limp
And powerless
To focus
My mind
On anything else;
If only you could
Hold the lamp of love
In my hard, dreary
Darkened path.

In its cool light
Of love latent,
And so omnipotent,
I will find my way out,
Even in the deepest
Abyss of darkness!

Thy will be done, obeisance!

HYMN TO THE RISING SUN! (16)

This is a humble hymn
To the glorious Sun:
The rising Sun,
The golden Sun
Raising our hopes for the day,
For the morn;
And the golden
Day, yet to attain
Fruition and perfection.

Golden ears of corn
Ripening to a golden hue,
Sway and whisper:
"How swell
And cool
Is the day!
How golden
Is the aura
Of our father -so divine;
A faraway shine,
Yet, our life breath's
Cause and origin,
Fulfilling a divine plan".

Adore you Sun!
Lover and father,
Abode of grandeur and lustre.
Stay, oh, shiny splendour!
Like the fragrance-
Of the westerly winds,
On your countenance:
Divine and God given!

Today (15-01-2011) Saturday, the Sun changes equinoxes and is celebrated as a festival called Makara Sankranti throughout India. The Sun-God is worshipped as the Lord of the universe and sustainer of life. Hence this weak attempt at capturing the glory of our golden Sun!

WHEN A PRAYER HAS POWER (17)

When a prayer has power,
What should I utter?
I deeply ponder:
God, your ways are
Alien to my mind's dark corner.

Evil's ways are
Always so sinister;
They often masquerade
As an affable keeper
Of a conscience,
So crystal clear.

Sometimes they parade:
A vain parade
Of false values:
Gems -so shiny and lustrous,
Before my gullible
And fool- hardy mind.

It takes the sharp knife
Of pure knowledge,
To cut and polish
A real gem of immense value.

What is just cut-glass
Will shower as glass filings,
As the vanity shows
Die their natural deaths.

Then the thing to wonder
Is that prayer has real power,
As it gives us
The knives
To scratch cut-glass,
And leave alone
The gems for the devotees:
The real and true seekers.

BUDDHA' S NIGHT OF ILLUMINATION! (18)

In the last watch
Of a full moon night,
When lovers embrace,
And gaze at the moon
With hearts full to the brim.

When the hungry vagabond
Has settled down to sleep
Without a morsel of food;
The fire in the pit
Of the stomach cooled,
By the shower of elixir
Sent down by a kind moon.

When the prisoner
Of the dungeon,
Has seen a flicker
Of the golden shower:
Playing hide and seek
With the tall air hole
Of his dirty cell.

When the whisper of the night
Faded away, floated away,
And merged with the sigh
Of the longing lover.

Time swung heavily,
Like the creaky pendulum
Of an old grandpa clock.
Thieves even took a break;
There is nothing precious,
To loot in such a
Beautiful night!

Mara, the tempter
Laid down his arms,
Before the Lord's sacred feet.
Sun dreamt of borrowing
From the Lord's aura,
As he sat in deep meditation.

In a flash,
All the universes sank
Without a trace
In a sea of light.
"Yours, mine and ours",
Empty bubbles
Burst forth and merged,
With the waves of happiness.

No shores with crabs
No whales and sharks
No octopuses and squids
No silver fishes
Leaping, on the frothy surface.

Only waves of serene existence;
Thirsts quenched forever.
None to call an enemy,
As you surf without sinking;
Your feet never sinking
Even without surfing!

"I am the light of all lights
Beyond darkness;
Shining beyond
The ken of the senses.
Embrace me to leave behind-
The shadow of the body,
As you face the Sun
Of knowledge!"

HYMN TO THE SUN-GOD (19)

Shine, oh, mighty one!
Lustrous, effulgent and the ancient one!
Witness to all actions:
Good, bad and indifferent,
Yet, egging everyone on
To ceaseless action;
The ultimate origin
Of all earthly energies!

Your effulgent core:
The birth place of many worlds
Unseen by mankind!
Your shining face:
The portal to the shining worlds,
Existing yonder and beyond comprehension
Of earthlings and even divine beings!

You send shafts
Of light and cheers,
So that we may rise from our beds
Of pain and misery,
And face another day
Basking in your glory,
And forget ourselves,
The pains
Of a meaning -less existence!

You nourish everyone,
With food and warmth.
The cold winter demons
Of frost and ice,
Are kept at bay,
By the slow fires
Burning in our hearths and bodies.

Your smiles of a past summer,
Slowly unfolding
Out of the glowing embers!
The flames and its tongues,
Another name for your
Bewitching face, with its
Winsome smiles!

The cascading waterfalls,
The ceaseless frothy waves
Dashing the shores,
The fishermen's sinews,
Shining with sweat drops
Glistening in the Sun:
Like rare pearls of labour and toil.

The ever smiling flowers,
The ripe succulent fruits;
All are nothing, but little, little parcels-
Of your infinite energy,
Sent down so lovingly,
By the adorable you: my Sun God!

Shine, oh, mighty one!
Cease not, till the whole earth,
Is nothing but one vast sea
Of effulgent light,
And darkness finds no hiding place;
Not even a brooding little corner.
All the living forms
Will then be nothing,
But, idols of your crystallized energies!

Shine, oh, mighty one!
Cease not, till you and I,
Are made of the same core
Of effulgent light!

INSPIRATION TO PEN (20)

"You are the result of what you thought"
Lord Buddha, on attaining Nirvana (state of supreme knowledge and consciousness), where the phenomenal world disappears and the distinction between the observer and the object of perception is lost. With apologies to the mighty Buddha!

Hail! oh, noble thought!
Propeller of the noblest
Deed and the greatest good.
Gets you to that state,
Where death has no sway;
And fear has no way
To enter and delude.

The Sun of pure knowledge:
Shines and casts
No shadows;
For, grief is just another
Name for the darkest hour,
Bearing its vilest fruit.

Eternal spring- a permanent settler.
Happy birds twitter.
Shores are golden,
Of this enchanting ocean
Of bliss- existence;
Even in a dream, none
Can feign pain!

Nirvana's shore
Is never too far,
If a noble thought propels.
Fills the belly of your sails
And sits at the helm;
Holding the rudder
Of the boat called the body,
Through the voyage of life.

ONE MORSEL OF FOOD - NEARER TO GOD! (21)

One morsel of food
Given to a pariah,
Takes you nearer
To God.

One palm full of grains
Scattered on the floor
For birds and nestlings,
Moves the wind,
To bring back the rain clouds.

The heaps of misery,
Gathered in a life time
Of indulgence,
Crumbles in a trice,
When a kind act
Fills a quarter of the tummy,
And evokes a tear.

God is then quick to hear
Your plea for more;
More to fill the mouths
Of the desolate and the poor.

THE FRAGRANCE OF VIRTUE (22)

"The fragrance of sandalwood and rosemary
Does not travel far.
But the fragrance of virtue
Rises to the heavens."

Lord Buddha

One spark flew
Away from the original fire.
I hear and adore
The master's whisper.

"The fragrance of sandalwood and rosemary
Does not travel far.
But the fragrance of virtue
Rises to the heavens."

The sledge hammer beats
The hot iron,
To shape it as a weapon,
Incessantly and ceaselessly.
Tear drops and sweat drops
Adorn my bulging sinews.

It becomes shiny and cold:
Ready for the kill
Ready for the King;
Thirsty for blood
And the bag of greed,
Filled with gold.

I have nearly forgotten
The first plough
I fashioned,
Out of the same fire.
Blown full and hot
By the same old bellows.

Now creaking and rusted:
The poor farmer's friend-
Loyal and devoted;
But still knows
How to laugh along,
With gurgling rivulets.
How to raise corn
To fill my tiny barn.

None an enemy:
The rat which steals
The grains,
Or the barn owl
Who preys on the rats.

The mind elevates;
The mind also pulls
You down
In the dumps;
You weep alone
Among the hellish delights;
Befriended by none
Other than your old enemy:
Desire for more.

Virtue subsides
Only if the mind runs
Amok, among the sensual delights.
When mind is subdued,
"The fragrance of virtue
Rises to the heavens."

THE BATTLE BEGINS (23)

When I get sickened,
By the stale breath of the old man,
And he gloats over his age and his kingdom,
His vicious dogs and his cunning ministers,
His empire of evil,
His garden of fly- eating plants,
His dark deeds and loads of deceit,
And his loyal and obstinate mules,
I long for thee and thy blissful countenance.

In the past, he sallied past forts of good,
Rode on a black- souled bison,
Brought down praying kings,
And made swimming pools of their blood.

While he sipped blood red wine
With wily women for company,
Mother earth walked on crutches,
And shed a river full of tears.

Then you arrived on the scene,
With a deafening roar and riding on a majestic lion,
His roar no less frightening.
Only maps made of the blood of the hounds,
And hides of the slain hordes of demons,
And their coiled entrails told of your savage fury-
And severe justice.
For "Light shall rule and not darkness"
Is your royal decree.

Times have changed, the hordes have reappeared,
As the children of the 'Old Man',
They no longer ride black buffaloes,
Instead they zip past in gleaming black limousines.

In what form you will appear I know not!
But appear you must, oh, lovely queen-
Of incredible beauty,
And we will begin all over again!

Thy will be done! Obeisance!
Oh Majestic Durga!
*Adore you Navadurga!**

**The nine supreme incarnations of Goddess Durga.*
Today (SEPT 19'th -09) is the start of another important festival in
India called Navarathri - literally meaning nine nights- celebrated all
over India. According to legend, the battle between Goddess Durga
and the demons rages for nine days and nights, till on the tenth
day morning, she annihilates the last of them. It is literally a battle
between good and evil, and on tenth morning called Vijayadashami,
to mark and celebrate the victory of good over evil, all Indians take
part in a victory procession led by the majestic Durga idol riding a
male lion. The old man in the poem is the chief of the demons called
Mahishasura - shown riding a black bison- as dark as his soul - the
king of darkness and its evil forces.

A SIMPLE PRAYER TO GODDESS! (24)

"Great ideas stem from God"
Albert Einstein

As I scatter grains
Against the backdrop
Of a rising Sun;
As the chirpy birds
Raise a big din;
The air is filled with
Twittering, chirping.

Beings made of light;
Gliding on the winds,
Perpetually and forever,
They always travel light.

Their wings,
Fluttering swishes;
Sound like pure laughter
Of one cosmic being,
Who has gone into hiding;
Nevertheless, whose laughter-
Reaches me as much,
As the golden sunshine.

The seeds I scatter
Are never sown,
For a bumper crop.
They never sprout;
Their only intention
To keep the hearth:
The fire of life
Burning bright.

The Sun smiles
And nods.
Knows it too well;
As he has lighted
All the fires
Of life,
From the primordial fire.

My only prayer:
Is to add one log
Of wood;
One at a time
To a small fire
Of life, burning somewhere.

Let it be in a hovel,
Or near the sentinel
Of a huge mansion,
Warding the bitter chill
Of a cold night.

ONE OF HIS KIND (25)

He is one of his kind:
Indeed a member
Of the rare breed,
Who has never seen or heard,
Of vicious hatred.

He has never read
Or spread any word,
Of philosophy
Or theology.
Nor whispered
The word 'God',
Even under his breath!

He has never entered,
The gothic arch
Of a majestic church,
Or the ornate corridors
Of magnificent golden - shrines.

Yet, his appearance
Brings smiles to
Man, God and bird.
The desolate man sees
His bread;
God sees his face reflected
And his herd.
The bird,
His grain and food.

Where has he gone
All of a sudden;
Riding the clouds
Of conscious thoughts
To his pristine Eden?

THE GODDESS OF GOODNESS! (26)

A hymn to the Goddess
Of goodness:
A pretty little Goddess,
Personified sweetness.
Conduct, guileless;
Words dipped in nectar.
Giver of solace and like a soft caress,
Soothing and encircling like a coil of bliss.

May I see you every day,
When the sunrise heralds another day!
The morning's delight and freshness,
Evident on your sunny cheeks.
Your smiles, like a flower bed in blooms.
Your gait like a baby swan,
Learning craft and grace from its mother swan!

Thank you, Goddess!
For appearing before me,
In the guise of a little lass!
I forget my woes and worries,
And the mad world's vain glories,
When I behold your innocent countenance.
Icon and idol of the cosmic Goddess:
In flesh and blood, and living-
To add to the joy of my living!

FANTASY

"A leap of fantasy overcomes the chasm between agony and ecstasy. It is also a bridge to eternity's shore of peace"

IF RAIN DROPS WERE TEARS (1)

If rain-drops were tears
Shed by fairies,
Then heaven is
No more heaven;
Sad fairies are more common
Than sad cypress.
What a thought!

Then mother earth,
She will shiver and shudder
As the rains pound her.
The succulent fruits
Of her green faced children,
Will turn blood-red,
Crying foul!

The whispering winds tell
That all is not well
In heaven and earth,
Fairies and humans
Both shed tears.
So does the mother of all:
Divine and human,
Fairies and earthlings!

A STAR IS BORN! (2)

Let me pause and think,
While others run
Races and win.
Let me watch the stars
And their shining light,
While others sleep
In stone -like stupor.

Let me forget the pain
Of living,
While rubbing a pain-balm,
To the one writhing in pain,
While others ignore and run,
Feigning an alien!

That, in essence, is the being
Of a man caught in a dust-cloud,
The lair of the stars
Yet to be born;
Somewhere in a distant galaxy:
In a nameless galaxy,
A star is born!

TWO BROTHERS (3)

Two brothers:
Not blood brothers
But soul brothers,
Set sail for the unknown lands,
In search of fame and fortune.

One deftly pulled the strings,
And the other set the sails
Free, as to fill their bellies,
With the welcoming winds
From the far-off lands.

When the rough seas
Rocked their boat,
Made it wobble on the angry seas,
One sat at the helm,
Expertly manning the rudder,
While the other kept at bay
The swirling waters
Hiding the evil headed sea-hydra,
Looking for a meal of the human flesh.

When the boat reaches
The promised land,
The first thing they will do,
Will be to hug each other;
Thank each other
And walk in step,
Rubbing shoulder to shoulder
To face every new adventure
In the unknown land,
Full of spotted terrors,
Striped tigers,
And painted cannibals.

Are not they, perfect soul-brothers
In the journey of life?
Crossing oceans
Full of death and disasters,
Slimy octopuses,
And black blooded
Hooded pirates,
Lying in wait with their crooked sabres!

WELCOME AN IDEA! (4)

Welcome all ideas!
Seldom they don,
Royal robes.
They look more like
Famished children,
Lost or abandoned
In the crowd.

But nourish them
Cherish them
Without any hope of
Reward or merit.

Who knows?
One day the royal messenger
May knock at your door,
At midnight- unannounced,
To show you the royal insignia,
And claim the long lost
Prince charming,
Princess of grace,
And invite their foster parents
To the palace royal;
For reward and honour:
A just reward
For rearing,
An orphaned prince and princess!

I BECAME A SHADE OF HAPPINESS (5)

I became a shade
Of happiness,
Shining from
The cheeks.
The faces:
Some cherubic
Some aquiline
Some long and ebony,
Some pretty
None ugly
But all full
With the joy
Of living,
And the festival of life.

 Am I the trumpeter,
The gate keeper,
The waiter,
The usher,
The event manager
Or the prince-
Charming of the fest?
None, whatsoever!

I am one with
The shining light
Of umpteen candles,
Kept on the tables,
Chasing shadows
And darkness.

Cause I am one
With the light
In your eyes
And the blooms
On your cheeks!
Happiness, you can
Borrow from my coffers!

A RAY WINDS ITSELF (6)

A ray winds itself
To its origin:
The bright and glorious sun.
A spark returns to
Its original fire,
To become a conflagration.

Every discovery
Begins with a hunch,
And ends with
A triumph.
One more triumph,
Over another fort
Of ignorance,
And darkness.

Sparks and rays,
Have kinship
With hunches;
So does the poet's
Frail quill has,
With test tube and retort.

A ray winds itself
In a return path,
To become one with
The sun of knowledge.

The ray is no longer seen.
But the sun is seen,
And admired,
As the Sun:
The glorious Sun!

CHASE A BUTTERFLY! (7)

Chase a dream!
Chase a butterfly!
Chase a dreamer child-
Yearning to fly!

Their dream
Yet, not in full bloom;
Weave a magic wand,
Even though you are no angel
To fulfil their dream.

Their innocence:
The fragrance
Of a bygone spring
In your life.
It is time to live
In the past;
At least, for a while,
To awaken the child
Within you!

Spring will knock
At your doorstep
Once again,
With its warm ardour,
Like a long lost friend,
Suddenly remembered-
And embraced.

Chase a butterfly!
Chase a dream,
Running away
With an infectious giggle!
You meet and befriend,
The fairy
Who rides
A butterfly.
A flying child,
Riding a magical carpet
Of a fond dream!

THE ENCHANTED MOMENT! (8)

The enchanted moment:
It fell from the sky
Like a shooting star,
Leaving a trail of light.

Like invisible dust,
On an unknown quest,
To bury its face
In the folds of night.

This very moment,
I am touching heart strings
Of my brothers and sisters,
Lazing around on a Sunday morn,
Or about to enjoy
An afternoon siesta.

You will all feel it.
See it, even in bright daylight,
Hear its melody above the din and bustle
Of traffic and city life.

What a divine fragrance wafting!
A zillion flowers smiling.
All aglow,
Is the inner man
With the shower of a sudden rain-
In an arid desert.
Watching it blooming,
As if a spell is cast
By a lovely fairy!

The cosmic Goddess smiles:
Everything is fine
On heaven and earth,
It is nice to be born
A human;
So, we can aspire to be divine!

THE SWING! (9)

The swing moves through the vast skies
Star dust and sparkling stars
Points of light
Rising columns of cosmic dust
Creation's ancient seeds
And falling stars,
From the positions
Of their exalted glories.

As it swings down,
It samples
The nether worlds,
Where creatures of darkness,
Prey on each other.

My mind- poor mind!
When a child swings
To and fro in a mirthful move,
It laughs aloud!
Like a timid child,
Why shiver and shudder
When you go through
The dens of darkness?
It is part of a plan:
A divine plan!

The festival of lights*
Is here to tell
The lasting glory
Of divine light,
Never fading and enduring,
Through mood swings
And fortune swings!

*Reference to Diwali – the Indian festival of lights.

THE LIMITLESS SKY BECKONS (10)

The limitless
Sky beckons:
Soar through new heights!
Touch the heaven's borders.

Fancy's wings,
Merciful winds,
Thermal air currents,
All will power
Your flight.

Your speck of white
Will soon merge
With the blue canopy
Of a serene sky,
And be gone.

The earth is lost;
So is its sticky desire
And unquenchable thirst,
To drink deep
From the dirty pools,
Teeming with mud fish.

Oh, free bird!
Oh, moment's poet!
You wield a quill
Which hops on the parchment,
Stopping for none,
Including the mighty time.

WHEN HOPES SOAR (11)

When hopes soar,
You fly!
When hopes are oars,
You paddle is furious;
Why then talk
Of a slow drift
To the isle
Of enchantment?

When hopes are dead,
They look like
The leafless tree,
Withered but not soul dead.
Come the first rain drops,
The green sprouts
Smile, emerge and whisper:
"Hope is never dead,
In the kingdom of life!"

ONE BIRD TOLD ANOTHER! (12)

One bird told another:
"Shake off your blues
Hereafter!
Preen your feathers
In the kissing beams
Caressing touch
Of the shiny father!"
Glorious and illustrious
Blemish -less father.

Sun is the father
Of today,
Tomorrow
And the day after.

He is the mother
Of the rainbow
After the brief shower:
An interlude
Of a drop of tear-
Of mother nature.

The grains we devour
Has a core made
Of sunlight.
The fire
In the pit of our tummy,
Is nothing but
The glory of sunlight,
Recalled at
A convenient hour.

As a dove pair flew eastward
In a poetry of motion,
And disappeared
Against the shiny disc
Of the rising Sun,
I uttered a silent prayer:
"My blues are gone too!
Like the morning mist
Fading away to
Morning's glory;
Blessed be thy infinite glory!"

I KNOW THE ONE WHO WILL
OPEN HEAVEN'S DOOR (13)

I know the one
Who will open
Heaven's door
For me now,
And forever, lovingly forever.

She will have wind tossed hair
Cheeks -the colour of sunset.
Eyes as blue and dark
As the vast shoreless sea,
Mirth bubbling over;
Will arrive donning tenderness,
Velvety and silky to the touch.

Her breath will have
The fragrance of a million lotuses,
All swaying, soaking in
The golden sunshine,
The honey bees will have
A honey drenched hum,
And a melodious drone,
As they make me slip
Into the slumber
Of a charmed existence.

I saw and I loved;
I sank and I drowned
And continued
To live, as I surfaced.
Found myself floating
On a sea of delight,
Thrashing my arms and legs;
Swimming delightfully
With my love's light
For company.

HIDE AND SEEK (14)

Pleasure and pain
Played
Hide and seek,
Laughing all the while,
Behind the wall
Of life.

I laughed,
I ranted,
I raved,
I cried,
Mystified by
That naughty
Pair of children:
Who only laughed
Never cried
Or ranted.

End of my cravings
Funeral of desires;
I join their game
Of hide and seek;
Never, will a ripple
Disturb my mind lake!

That is a vow
On the eve
Of the infant
New year, learning
To smile.

THE DARKEST HOUR IS OVER! (15)

The darkest hour
Is over.
Forever, over.

Dawn has donned
Her princely white satin gown,
Shining like a filigreed
Princess's royal robe,
Accompanied by flower-maids,
Smiling soulful smiles.

Lo, behold!
Her chariot is rising,
Happiness and cheer,
Shining light and sun shine:
Her retinue-descending,
And the hope of a new-day:
Her magic –wand
Casting its spell:
A wondrous spell!

IT IS GOING TO BE A BUMPY NIGHT (16)

This poem is dedicated to the memory of Charles Lindbergh's epic flight of the 'Spirit Of St.Louis' – a single engine monoplane from New York to Paris 1n 1927- a remarkable feat and tribute to the human spirit's power to endure and overcome insurmountable obstacles.

The mind fears,
The mind shudders,
The spirit propels,
Dares and overcomes.

Reaches the shores,
Holds aloft
And unfurls the flag of victory,
Amidst cheers and shouts,
As champagne spills
With frothy smiles.

Long is the night
Of vigil,
Dark clouds may hide
Angels of death,
The rough Atlantic waves
Are concealing savage jaws,
Of death, rimmed with
Elephantine tusk teeth.

It is going to be a long ride:
A bumpy ride,
Frequently tossed up
Against an ominous
And sneering cloud
That whispers:
"You fool! How dare
You ride above me
You -man - a mere mortal?"

My soul whispers;
Utters a caressing:
Sweet nothing.
"Fear nothing, I am deathless!"

I am the little silvery fish,
Swimming among the happy clouds,
As the sun smiles
Through the portal
Of delight on my plane,
And as I see the shores
Growing in size,
Rapidly and smoothly,
I know that
Victory is in sight.

I only remember my soul's
Ardent pleas-
And advice throughout
The long and dark night:
"Fear nothing, I am deathless!".

The rest is history:
And a tale of victory,
A feat -
Which changed aviation history.

WHEN ONE THOUGHT OF SOLACE (17)

When one thought of solace:
Solace unalloyed
And pondered on the paths,
Which lead to
Its blessed abode.

The enchanting feel
Of a divine melody,
First heard;
Ever remembered,
And you wondered,
About the soul blessed,
Who had it composed.

When you read
The charmed word
Of a quill so blessed,
Pondered,
Chewed it like a cud,
You have become the holy cow:
The holy cow
Who grazed
On the lush pastures,
Green and blessed
By the great munificent God.

When you hugged
And kissed;
Shed a tear
So tender
And love filled;
Entered a kingdom
Where love reigned:
None wielded a cruel sword.

I wondered, pondered.
Weaved one more thread of solace,
Onto the fabric
Of life.

I still wait for the
Magic of the spoken word,
To spread waves
Of solace
All around.

Give it to me,
Oh, mighty Lord!
Goddess of the blessed word:
Omniscient and kind.

HOPE IS REBORN (18)

Hope is reborn
Every morn;
And does not die
By the night.

Dreams are the fireflies,
Who shed a little light,
Even in the darkest
Of nights.

Hope is the mother
Who provides
The means,
To make them breed,
Even in the soggiest
Of marshlands.

Delighted to pen
This thought
Worth a penny.
May or may not
Be true,
From the look of it!

But live we must,
Holding on to
A benevolent and magnificent thought:
Born in the cradle
Of hope.

A FAIRY LAND BECKONS (19)

A fairyland beckons:
Smiles and cheers,
Buds and flowers,
Caressing happy thoughts.

Death's shadows
Do not enter,
Nor they play
Hide and seek,
With a carefree laughing life.

Bubbles burst every moment;
Not a bubble of hope
Or a fond dream,
Clasped to a love -lorn
Heart aching within.

Neither frogs and princes charming
Nor sleeping beauties,
Seen around.
Only a dream blooms
To come true.
That is what matters,
In this enchanted island.

Fairy land beckons!
I set sail,
On a raft of contentment,
Never to look back
And sigh, in a life time.

I LONG FOR YOUR CARESS (20)

Bliss!
How I long for your caress!
Minutes and years
Fly and roam;
That does not affect
My princess.

All smiles,
Tears never again,
As you suddenly burst forth
From your hiding;
Like a peppy girl
Shaking all over,
With mirth
And laughter.

Princess Bliss,
Forever be my guest,
Till the travel
Weary and forlorn
Stranger comes to town,
And you will meet him
At supper
In my modest quarter.

Blessed are your footsteps,
Which never retrace
Once you enter
Home -sweet home.

Princess Bliss,
How I long for your caress!
Peace and solace:
Your mace and crown.

YOU MAY LEAD A HORSE TO WATER (21)

My mind!
Why you refuse to heed
And bend?
Learn to follow;
Allow to be led?

Like the fabled
Stallion of old,*
Who got bewildered
By watching his shadow,
Growing long
And big.

Got frightened,
Reared and trampled
His rider and fled,
Raising dust and fear.

Till the man of wisdom
Arrived and found:
That the stallion
Stood with his back
To the Sun,
Watched his shadow,
Feared it and bolted.

When he was made
To face the Sun,
No shadow was
Ever visible.
That marked
The end of all trouble.
The unruly horse
Was thus tamed.

How wrong I was
To assume that
He will drink
From the clear limpid
Pool of knowledge.
Alas, he still refuses
To drink from this pool;
Cause, he still is
Not thirsty for knowledge.

"You May Lead A Horse To Water, But You Cannot Make Him Drink"

I SHUDDER AT THE THOUGHT (22)

I shudder at the thought
Of a visit to heaven;
Because I have to
Return to earth,
Some time!

I long for a visit
To my teacher- so great;
Because I never have to
Return to my corner:
A blind and treacherous corner,
Without an idea,
A clue as to
Which way I am going!

GRACE FLOWERS (23)

Grace flowers:
Magnificent flowers,
Holding nectar drops
Ripening in the sun,
Magnificent lotuses:
Eye catching and breath taking.
Ornament of the king's garden.
Pride of place
In his magnificent court ponds.

None sees
The smelly mud and mire
Which nurture
The delicate fragrance.
It has no kinship
With the laws of nature.

Grace flowers:
All smiles!
Gives us hopes
Of a divine ascent,
To the gardens up and above.
Laws of nature are now silent,
In mute wonder!

BRIDGES MADE OF LIGHT (24)

Bridges made of light:
Feather weight,
Lighter than feather,
Made of light,
Pure and soul's delight.

I roll them
Like a magical carpet,
Bridging the oceans,
Continents and countries,
Spanning cultures
And creeds.

Welcoming you on a trip,
To the shiny worlds above;
To have a glimpse,
Of what lies
At the core of galaxies.

To nudge the ring
Of shiny nebulae,
To roll in the shiny sands
Of the milky way,
To take a plunge
In the effulgent ocean
Of light!

To swing to and fro
Through the maze of stars,
Grabbing a few
With bare hands,
All aglow-
Like a child at play,
Rocking and swinging.

The day is long;
The good deed done
During the day
Will never fade away,
Will multiply and return
To bless and be blessed;
Rejoice! The entire world!

A LONE SENTINEL! (25)

A lone sentinel
Stood at the doorstep
Of my ancient
And old fort,
Called the mind.

Enemies galore:
Serpents slither,
To glide in
Unnoticed,
Venom filled
And looking for food.

You see them all;
Kill them all!
Were you to close
Your eyelids,
Or bat them for a moment;
Where I would have been?
What would have happened
To my ancient
Most beloved fort?

Thanks, my dear sentinel!
Little did I know
Of your allure;
Or your eternal vigilance,
Oh, fond princess!
My own pristine soul:
Daughter,
And apparent heir
To the throne of
The cosmic queen:
My cosmic mother-
A truly divine mother!

FAIRY TALES ARE MORE REAL! (26)

Fairy tales are read
And listened to,
With eyes open wide,
By children who love
The flights of fancy,
And the child at heart,
Known as an errant adult!

Frogs loving kisses,
Kisses making princes,
Fairies riding butterflies,
Sleeping beauty waking
From slumber, to greet
The prince- charming!

All real and happening,
More real than
Reel heroes,
Their smiles, jaunts and utterances,
Stock exchange crashes,
And celebrity deaths!

I BURY MY HOPES EVERYNIGHT! (27)

I bury my hopes every night;
Only to see them sprout,
By the morning's divine light.
I smile in delight.

"You vagabonds
And orphans:
Dead souls of the night!
How did you outlive
The stinking clods of earth?
Or the cold stones
Of harsh beds;
For yet another night,
Without life giving Oxygen
And water: the elixir of life?"

They smiled and sang in unison:
"We were born- reborn again
After being buried alive by the hot sands
Of a sad Sahara!
We survive the bone chilling
Cold of a biting Siberia!"

"We are angels without wings;
Flying through rough weather,
Air and ether
With equal flair,
On wings of absolute faith.

After every dreary night,
Sad and long night,
We are reborn again,
With ethereal- corporeal bodies
As the morning's fresh delight!"

I bury my hopes every night;
Only to see them sprout
By the morning's divine light!

HAPPINESS AT WHAT PRICE? (28)

Happiness
At what price,
Oh, wayside poet?
You never learned
Your 'three R's
In scholar's company;
Or the elite school-
Of the rich and the powerful!

Why this vain reverie?
Everyone's eyes
To be filled with love's
Magical potion of the fables:
Like in 'Mid Summer Night's Dream'.
Wake up to love
The first one -
To set eyes on!

That is a futile wish
May be,
May not be;
I, for one
Will dream of the day,
When love will coo
Like the dancing dove.

Then, happiness comes
At no price.
It is free for the contented
Bee of my back yard,
Having paid no price
For the flowerpot
Of elixir,
For its lover:
The honey suckle!

THE HALL OF MIRRORS (29)

I enter a hall of mirrors,
All alone.
What grotesque faces
Meet my glances!

Some enchanting
Some scowling
Some outrageous
Some comical
Some sad and melancholy
Some bubbly and mirthful!

I soon lost myself
Among the maze
Of the faces,
And I wondered:
Which one –the real me?

Oh, foolish mind!
Which mistake
A reflection
For the original,
Do you have an answer?
I indeed wonder!

THE WISE PRISONER (30)

Once there lived a prisoner
Who was imprisoned,
Not due to his evil deed,
But because destiny planned
Such an end!

While other fellow mates indulged
In destructive deeds,
And drunken brawls,
He was firm as a rock,
In his resolve:
To outdo the destiny's wicked
And sordid thought!

The others demanded,
And got what they wanted:
Luxuries and more and more ways
To outwit the time demon's
Wiles, guile and traps,
And his sardonic smiles.

The wise prisoner had a shield of faith,
And an armour of fortitude.
He only sought solace
In a righteous thought,
And an equally good deed.

He got indeed
What he wanted:
A reduced sentence.
The prison walls crumbled
Right before his eyes,
And he was free once again.

Destiny frowned,
And looked the other way!
Is not he wise
Beyond compare?

Breakers and waves
Are indeed powerless
To break a majestic cliff,
However hard they may go at it,
With their whip-like lashes
And hideous hisses!

HOW STRANGE IS
THIS BIRD OF COMPASSION! (31)

How strange is
This bird of compassion:
It does not vie
With other birds
For grains,
And bread crumbs.
It does not have,
A beautiful plume;
Not much to look at!

But it sang such a beautiful note
Before it flew away,
To its dwelling place
Somewhere in a faraway forest.

Stranger to city dwellers;
Stranger to other birds,
Who fly and hop
In my courtyard.
Filling their crops,
And sing happy songs
With mellifluous notes
Of satiation, thereafter!

How strange is this bird
Of compassion;
Whose melodious note
Once heard, lingers
For a lifetime.

WISHES AND HOPES (32)

Wishes and hopes
For fresh beginnings;
When your joy ride
Has ended in a road-block.

The horse is tired,
And also in no mood
To get on the road.
His mouth foaming,
And his shaking head,
About to begin the neighing!

The road is long and crooked.
That hardly matters
To the horse and the carriage.
A brief rest and respite
And a few morsels of food,
A good drink of water,
That is all that he needs,
For now.

Oh, my poor mind!
You are tired and drained,
Why not you renounce
Your desire to take
The road not much travelled,
When your horse
Is drained and exhausted!

NATURE'S LAP

"Mother nature's lap, a last resort for all world weary souls. None an outcaste; an ant and elephant- an equally honoured guest- in her joy-filled mansion"

ODE TO THE VANISHING TIGER! (1)

The royal Bengal Tiger- the pride of Sunderbans forests-is slowly fading out of our sights and minds. This ode is inspired by a dire need to conserve this magnificent national animal of India.

Once tall grass
And green shoots
Could never hide your prowess
Or your majesty
Oh, great stripes:
The royal Bengal tiger
Who stalked and hunted the black buck,
The Cheetal- the spotted deer,
The Sambar and the Nilgai,
In a style, fit for a prince
Of the dense forests!

You rose as a picture,
Larger than life.
Filled the pages
Of Rudyard Kipling,
And gave birth
To the fabled jungle tales.
Age could never eat
Into your glory,
As you roamed around-
Fuelling childhood fancies,
The uncrowned prince!

You left the snow clad steppe
Of the Siberian chill,
To acquire a new majestic coat,
Fit for an Indian prince.

Alas, your magnificent coat
Proved your undoing,
As poachers waited
With poisoned baits,
And mean guns;
Their eyes filled
With the greed,
For the fortune in dollars
Your life-less coat fetched!

Hope, your orphaned cubs,
Crying in the wilderness
Will enchant us,
Like the ever playful puppies;
As caring people all over
Will raise them,
To make them regain the crown,
Of a long lost prince
Of the forest!

Good luck, stripes!

LOVE YOU, LITTLE SNOWFLAKE! (2)

Love you, little snow-flake:
Fallen from the heavens,
But never lament or wail
About your great loss,
Of the effulgent heavens
And its zillion stars,
Golden fairies;
Their pretty magical wands;
Mercurial wind Gods.
Chariots of fire,
And the level playing fields
For the mighty Gods,
Where mirth rolls;
Rolls and laughs,
Never sighs!

You roll down
And spread the carpet
Of virgin-white,
For the winter-queen.
Pricks me with the needle
Of pure pleasure.
I close my eyes,
Savour the fresh taste
That you only can bestow.

Ornate crystal,
Chiselled and carved,
By invisible hands.
Hangs icicles
By the dozen,
Shining like huge chandeliers,
On my fence-trees,
Like the winter queen's
Ball is about to begin!

Love you, little snow-flake!
Winter never gives
Me the blues,
As you and I carve a snow man,
Dressed in bright red clothes,
Spreading brightness
And cheer
Among shivering men,
Made, alas! of flesh and blood,
And never of pure snowflakes.

HYMN TO THE MONSOON-GODDESS! (3)

Hail!Oh, beautiful Goddess!
Shake your luxuriant locks,
And there will be showers
Of nectar-drops:
Another name for rain-drops,
For the tillers and the farmers.

I can see the sinister shadow,
Of a famine growing
Like a mountain.
I can hear his sinister laughs
Behind the hills.

Men reduced to moving skeletons,
Children have no milk-drops
Left in their mothers'
Shrivelled breasts.
Their eyes lustreless,
And have sunken in deep pits:
Fathomless pits
Of poverty and depravity.

Oxen cannot stand,
Breathing fast, they lie quiet
For the great redeemer-death,
To end their life
And misery.

Lo, behold!
The sky is lit up
With the lightning tree,
And against the backdrop
Of the dark and ominous clouds,
A silvery shining form:
Enchantment crystallized-
Is descending,
Majestically riding
A magnificent lion!

As the incessant rain drops
Pound the roofs,
And the happy, screaming faces
Shout themselves hoarse,
The rain dance has begun:
The cripple is dancing,
The old have thrown away their staffs,
The cattle have stood up,
The calves are running
In joy- filled circles.

And I know:
That your grace has arrived,
Not a minute earlier,
Rain drops are now, nectar drops!

THE HOUR OF SPLENDOUR AND GLORY (4)

"Though Nothing Can Bring Back the Hour of Splendour In the Grass, of Glory in the Flower"

Wordsworth

Yet, the splendour remains!
Poets young and old
Soak their souls,
Dip their quills,
And quiet flows
The stream of words,
Enriching lives.
Making moments
Crawl and not run.

Oh, you slippery snail!
Why did you leave a trail
Of a sticky tear?
Weep with eyes
Without lashes,
About the lost spring.

Oh, you song bird!
Why you stopped
Midway, to listen
To the whisper
Of the night.

Flapped your wings,
Breaking the silence,
Flew away into the folds
Of the night
To let the melody
Remain, like
Futile love
In a Greek tragedy!

Though nothing can
Bring back the hour
Of splendour
In the grass,
Of glory in the flower,
The words:
Mere words,
They fly
To the edge of the universe,
To bring back the splendour!
And by Jove, a poet is reborn
His words- worth,
Unknown!

THE FIRST RAIN DROPS! (5)

The first rain drops
Fell, felt like nectar drops,
From the flowers
Of the celestial gardens.

Mother earth's parched lips,
Opened wide.
Her hot breaths,
Escaped as vaporous clouds,
Along with her sighs
Of relief;
Whispers of joy-filled
Sweet nothings.

The boisterous monkeys
Went into ecstatic chatter,
And played hide and seek,
With the swaying
Rain –drenched tree tops.
The baby monkey left its mother's udder,
And watched the falling rain drops
With open eyed wonder!

The peacock spread its
Heavenly plumes,
And showed its wondrous
Trillion filigree velvety-feather eyes,
And strutted in long strides,
A prelude to its
Dance of the monsoon –delights.

I peered out of the windows,
Saw bells of the wild flowers
Fill to the brim,
And overflow as blessed drops.
Falling on mother earth's brow,
To begin the cycle of green,
All over again.

As the hurried calls of the wild birds
Egg its offspring to open its beak
To taste the nectar drops,
Echo through the thickets,
I fold my hands in prayer and thanks,
For the grace that has arrived,
Finally at my doorsteps.

WELCOME SNOW (6)

Welcome snow!
Welcome, the first fall
Of the icicle,
Ornately carved,
Pure and white.
Deft fingers and fine art
Rolling the carpet
Of welcome
For the winter queen;
Her entourage,
Her wispy white cotton
Flakes and sheets.

When snow melts
My heart melts
I adore the winter queen,
Her flakes and sheets.
Gone is my love,
For yet another year!

A DROP OF GOLDEN SUN! (7)

They say:
That the sun was born
To blaze a trail,
For specks of dust
To embrace each other,
And become a shiny star.

There are billions
Of stars
Shining somewhere,
Beyond the regions
Where eyes can hope
To reach and dwell.

But, all of us are
Given at least,
One chance to become
A wee bit shiny star,
In someone's life
Sometime, someday.

That will be the happiest day
Of a kingdom,
Which will be ruled
By never an emperor,
But a shiny star:
Called the beaming sun!

ADORE YOU! OH, LITTLE FLOWER! (8)

Adore you, oh, little flower!
Bow before you, beautiful flower!
Your roots in mud and mire,
Your fragrance reaching
Heaven's privy door.

Admire you, oh, little flower!
How you change
A rain cloud's tear
To heavenly nectar!

Love you, oh, little flower!
You add to the fragrance
Of my beloved's silken hair;
Joy to the evening's cheer.

A lover's tear
Changes to a beautiful smile,
Cause you learned
And taught us,
To smile all through life,
Fenced by prickly thorns!

Adore you, oh, little flower!
Adore you, oh, big flower!
You taught me in a whisper:
There is no big and small
In the kingdom of beauty;
In pots of nectar,
And butterflies' choices
To savour the nectar!

THE WONDROUS SEA (9)

One drop loses itself
In another.
One drop grows bigger
And loftier,
By loving another.
Many drops merge and flow,
And become the mighty river.

Big rivers, small rivers converge,
And find rest,
At the end of their ardent pursuit,
In the bottomless ocean.

Fathomless depth,
Also vast expanse of serene blue.
Eyes cannot see the end;
Except the rim of the horizon.

Mind can only visualize
How deep it can go down,
Till it reaches the treasures
Buried in the vaults
Of mother earth's secret chambers.

Waves and shores,
Embraces and sighs,
Frothy laughs,
Bubbly farewells,
Racing waves
Crashes and cries
Swooping seagulls:
Floating white birds,
Bobbing with the waves.

My musings
And my thoughts
Fill up with awe and wonder,
Of the one who loved this picture.
Saw it all in its pristine glory!
Before deft hands
Painted it with an exquisite touch,
For all of us to see;
Ponder and wonder!
The wondrous sea,
Deep, as deep can be!

MORNING GLORY- EVERY MORN
YOU GREET ME! (10)

Morning glory!
You bring delight:
Every morning you greet me
With a velvety violet smile!

Your cup of happiness
Full to the brim,
Your smiles
Unfold the glory of the moment:
Glory that is transient,
Which will wilt,
As the sun climbs to
Its zenith.

Nevertheless,
Your smiles never shrink,
As the moments
Dissolve in the river
Of time.
Faded and folded,
You remain and retain
Your charm and allure,
That is for me to wonder!

A ROSE PETAL BORE A TEAR (11)

A rose petal bore
A dew drop,
Which became much later
A tear drop.
A greedy grasshopper
Started munching the tender leaves,
The soft heart
Of the scented flower,
Finally its moist
Private chamber.

Why, oh, grasshopper!
You are not satisfied
With grass and green?
Why you want to invade
Beauty and its crown?

A thing of beauty:
A beautiful Rose
And its velvety petal
Bore a tear.
A sad tale:
Beauty and beast coexist
Till the beauty disappears
Forever, beast the victor!

Oh, sharp beaked fly catcher!
You are our saviour:
You are the beloved
Of the sleeping Rose bud,
As you feast on the grasshopper.
Now, beauty shall remain forever:
The final victor.

TALL GRASS AND PRICKLY WEEDS (12)

Tall grass and prickly weeds:
Eyesores on flowerbeds,
Fragrant Rose gardens,
Misfit to share spaces
With Daisies, Lilies,
Morning glories and Carnations.

They have their territories
Earmarked outside the garden-fences,
And fixed hours,
For slaughter on the blades-
Of a happy, humming lawn-mower.

Still they smile at me,
Every day, day after day.
The prickly weeds,
Weave a yellow floral crown,
To welcome the sun,
The cool morn.

The tall grass
Offer a velvety wool dress,
Made of feather -soft flowers
For the chills of
The winter morn.

Weeds and grass,
Know how to smile
At the splendour
Of creation,
And the merciful creator
Likes Roses and Lilies.
The creator in turn,
Has frown for none.

The benevolent Lord:
The ancient one,
Has a smile for everyone:
Roses and weeds
Tall grass and Daisies;
Called the bright sunshine.

WAITING FOR THE DAWN (13)

I am waiting for the dawn,
To break in.
Impatient and eager,
Listless and passionate,
For the dawn to break in.

I want to be the sunshine,
Which gives a rare shine,
Even to a mud pool:
A stinking cesspool.

I want to hang pearl drops
Where tear drops
Once stayed and reigned;
Cause I am sunshine
Lustrous and eternal.

Today somebody, somewhere
Will perform
A decent burial
Of their sorrows,
Never caring to cast
A fleeting glance
At its tombstone.
Cause, I am sunshine:
Life giving and lustrous.

Rise and run
Oh, down trodden!
And the fallen swine!
In me, you will find
A God send;
To care for you,
And propel you
To the battle front.
Emerge a true victor!
Cause I am sunshine;
In the clear light of mine,
No enemy remains ever hidden.

ONE ROSE AND ANOTHER (14)

One Rose
And another,
Smiled at each other-
Contented.

No competition
No green envy
To vie for,
The crown
Of the beauty queen.

I learned from them,
Watching them sway
With delight,
As hordes
Of bees
Descended for the love-feast.

No fight among the bees too,
To get close
To the nectar pot,
Or the moist
Chambers of their beloved.

Why cannot man:
The higher creation,
Learn from those
At the lower rung
Of creation?

That is the question
Which will engage
Us all, as I walk
In admiration,
Absorbing deep within
The divine scene.

WE LIVE ONLY ONCE (15)

We live only once.
We need not love
Only once.

The pearl white clouds
Change their faces,
Darken and frown;
Angry streaks of lightning,
Rumble and thunder.

Mother earth does not shiver
With fright and fear;
For these are the moods
Of her lover,
Which she simply adores,
Before the showers
Begin their dance,
And the rituals of creation.

I love all the moods
Of mother nature;
Sombre, gleeful, pensive,
Brooding and fun filled;
Above all, loving!

We live only once.
We need not love
Only once.

THE FIRST WHISPER (16)

As I hear
The first whisper
Of the new morn,
As I watch with
Bated breath
The glow in the east,
A veritable feast
For my soul:
The inner artist,
I wonder:
Is it the blush
Of a coy new bride
That I behold,
As I see her
Walking down
The aisle,
With hope in her soul
And dream in her eye.

The majesty
Of the Sun,
As he rides the chariot
Of fire,
Drawn by the seven horses,
Is mystic lore;
I see neither the horses
Nor the chariot,
Save the glory
Of light as it bathes
Me and my dreams,
In an aura of light:
Golden light,
The colour of a soft
And fond dream.

I hear the first whisper
Of the new morn.
I see the glory
Of light divine,
"Forget me not,
The glory of light"
Is the dawn's theme song.
I am all ears!

FIRE, OH, FIRE! (17)

Fire, oh, fire!
What a face!
Such a lustre!
Born with warmth;
Giver of light
Ever so pure,
Bright and full of cheer.

Bakes us our daily bread,
Cooks us our daily food
Lights us so many lights:
Ornate birthday candles,
Delight of all the parties.

Drives our antique
Putt-putty old steam engine,
Puff, puff! the smoke billows
And drags our carriages;
Chirpy friends
Laughing friends
In a fun-filled,
Merry go-round.

I could write pages
And pages,
So many tales
Of your riches
And glories;
Enemy of the snow-demon,
Sleet and frost,
Biting cold
And prickly wind.

Hug me and hold me,
And put me
To sleep in the
Warmth of your embrace!

Fire, oh, fire!
Friend of the poor,
And friend indeed,
When it is so cold!

A MOTHER BIRD HAS LANDED (18)

A mother bird has landed
On its nest,
With food in its mouth
And love in its small heart.
The flutter,
The quiver,
The joyous answering flutter,
The little greedy mouths,
Agape with voracious appetites.
The happy chirping
Of the nestle,
Echoes as the forest's
Delight and desires.

What if the mother bird is not seen?
Her love is heard,
Above the drone
Of bees and crickets,
Intent on the song of the spring!

A COOL MORNING (19)

The morning is cool:
Cool breeze
Cool butterfly
Cool smiling darlings
Called flowers.

Little Lilies,
Eternal glories,
Yet, more real than royal robes,
And one-day wonders.
Charming smiles,
Charmed lives.

Sliding little wonders
Full of life and laughter,
Their laughter echoes
In the park,
And make the oldies
Jogging and bathed in sweats,
Stop in their tracks.

Sun streams and sends
Celestial chutes
By the dozens,
For the dreamers
And the lovers,
The indulgent poets
Climbing to greater heights.

AN EARLY SPRING! (20)

When fog envelopes
And everything disappears
Into oblivion,
I hear the frost demon's
Sinister howls
And sneers;
Shivers with cold fingers.

Search for warmth
Deep inside me.
Soul warms up to me.
Gone are the shivers,
And frowns of the chills.

There is spring in my step
I jump, sway
And dance;
Spring is early,
And warmth is not far behind.
Smiles and rites
Of an early spring,
Welcome to my doorstep!

The first grass flower
Is welcoming you,
With a full smile
And velvety carpet.
There is a spring in my step,
As I smell
An early spring.

WELCOME Oh, GODDESS OF SPRING (21)

Joy is in the air,
There is spring
In everyone 's step,
Spring Goddess
Will soon be here.

Paint your face
Oh, pretty Rose,
With all the hues
Borrowed from your lover:
The smiling tropical sun.

Look as bright
And satin white
Like a coy bride
In virgin white
Oh, delicate lily.

Arise, and hold yourself upright
Oh, magnificent Sunflower!
Your beloved sun
Will cool his touch,
As you greet him
With a face, full of smile.

Fill the air
With invisible hands;
The fragrance of the heavens
Oh, frail and thin
White faced Jasmine.
Soon, the bees will be drunk,
And sway in a trance:
Their own
Dance of the spring!

Me, as I breathe in
The joy of a cool spring morn,
Grope for words
To depict the glory
Of the event:
The advent of the spring;
The descent of the Goddess
Of spring and hope!

PRAYER TO SUN (22)

Cease not to shine
To give solace
To those
Who live
In the shadow
Of a nuke catastrophe.

You the sustainer,
You the portal
To the shiny world beyond;
You the redeemer:
The nearest neighbour
To God and his kingdom.

Let no mushrooms:
Ugly, hideous!
With poisonous fumes
Rise and fill the skies,
Cutting off the Sun
From our sights,
And make us despair
About an absent tomorrow.

Thy will be done,
Oh, effulgent face!
Wipe a tear
From every face,
And the shadow of grief
From every life.

GREET THE SUN, GREET THE MORN! (23)

Greet the Sun,
Greet the morn!
Greet the flower
With a full smile on!
Greet the rain;
Ignore the dark cloud:
Brooding and sad.
Greet the silky sheet of blessing water: rain.

Rain, which is a shower of nectar
For the toiling farmer,
And the end of his despair.
My hopes rise in the air;
Soon they will touch
Cloud nine.

As the church bells chime,
And call the faithful,
For prayer
And congregation;
God is in heaven,
Peace is in the air!

Full is my quill.
My heart is full!
Greet the Sun,
Greet the morn!

A BUD AND A FLOWER! (24)

A bud
And a flower
Borne on the same branch
Awakened me
From my reverie.

One year is drooping.
Its petals fading
And falling;
Another bud
Is hoping;
Dreaming
Of blooming
Under a benevolent
Plentiful sunshine.

Bud and child
Dream and hope;
Write the script
Of the future,
Whose face
Remains hidden
Under the veil
Of time.

Good times
Or bad times
Or their admixture
What it holds,
I know not;
Except that I
Will continue
To adore and watch,
Flower and bud
On the same branch.

IN MOTHER NATURE'S LAP (25)

In mother nature's lap,
I went for a brief siesta.
The world is dead;
The people have vanished.
Hopes, dreams and desires
Are banned,
At least for now.

The flowers smiled
When I went in;
They continued to smile
Even after I returned.

The clouds painted
The sky - a pale grey
That was before my slumber;
Now the sun is shining.
The skies are blue
Once again.

The clouds have shed
Their burden and tears.
Rain drops
Hang necklaces;
All shining and glistening,
For the monsoon princess
Lying on tall grass.

A lone eagle is riding
A rising wave of air.
It is looking for a prey
Amidst the sunflowers-
Perpetually all smiles,
Hopefully, there would be no stains
Of fresh blood,
On the carpet of green meadows.

What did I lose during my sleep?
The smiles of mother nature
Have not vanished
Even a wee bit.
The flowers are smiling as
Ever before.

THE SEA IS SERENE (26)

The sea is serene,
Vast and blue,
Limitless expanse;
Fathomless depth.

No bounds for you;
For, horizon
Is pure illusion:
A sheer delusion.

As you kiss
The skies,
What emotion
Stirs your brow?
Alien to the poets,
And fumbling writers!

The sun goes down
At sundown
To take a plunge;
To cool his core,
Effulgent and hot,
To rise again
Another day,
To shine brighter,
To make our day
Lighter
And ring in laughter.

Sea, the friend of the mariner.
The brave explorer
Who set sail
To charter your empire;
You never sank his frail boat,
So that we can now ponder,
And wonder about
Your size and splendour.

Sea of pure wonder,
Blessed be the quill
Who wrote about you,
And did compare
You to the vast
Ocean of knowledge:
Vast, limitless.
Inspires our awe
And sheer wonder!

CAN I BORROW A SMILE
FROM YOU, MY SUN! (27)

Can I borrow a smile
From you, my Sun?
Soaked in shine;
No tinge of sadness
Forever,
Of darkness and wile.

How you shine and reign,
High and up
Above the sand dunes,
That try to pile up the riches
Of the glorious flowing sands;
Their fortunes
Swept away in a moment,
By the furious winds
Of change:
Desert storms- restless storms.

Nothing is left
But the sea of sand;
Only commoners remain-
Tending the caravan.
You continue to smile
Your all knowing smile!

Can I borrow a smile
From you, my Sun?
People pile up riches
And end up losers;
You still continue to smile
Your all knowing smile!

SUNSHINE AFTER THE BRIEF SHOWER (28)

Who would not like
The sunshine after
The brief shower?
The grey slate
Of a pale diseased sky
Wiped clean;
It is now blue and serene.

The dark forebodings,
The black evil clouds
Have spent their fury;
Mother nature's last raindrop
Is no longer a tear drop;
But a beautiful pendant,
Adorning a grass queen!

The Sun has been
Washed clean
As it looks;
His smile now dissolves
In mine,
Who would not welcome
The bright sunshine,
After a brief shower?

ONE FLOWER SMILES BETTER
THAN THE OTHER? (29)

One flower smiles better
Than the other?
I asked about this wonder
To the benevolent sun;
Benefactor,
Who provides the succour,
Our lord and master!

"No way!"
Answers the all knowing Sun;
His dazzle,
A wee bit less,
As a deep thought
Crossed his shining,
Effulgent, lustrous countenance.

One wild flower
Has the same smile:
As alluring
As a beauty called Rose.

A smile is a smile;
A flower is a flower;
Whatever name you choose
To call it.
All equally dear;
Endear themselves
To my shiny self,
With their sinless smile.

"What is in a name?",
Asks Mr. Shakespeare.
I agree!
What is in their smile?
Guileless innocence,
Like their illustrious father,
Shining through the portal-
Of an effulgent shadowless heaven.

ICE PRINCESS, WHEN WILL YOU HANG ICICLES? (30)

Oh, sweet ice princess!
When will you hang icicles
On my fences,
And grow fingers,
Cold and hard,
Yet, alluring to watch,
As they crumble
And fall
After a while.

Shovels full of snow
Cast aside,
To harden and ease,
The passage of the ice princess.
Behold her reign,
Which will begin
Very soon.

Snow is a family
Without a stain
And a blemish.
All wear white gown,
Made of pure satin,
Silken to the touch
And like the coy bride,
Shine in virgin white.

White carpet
Welcome for the queen,
As snowflakes rise
And dance on the
Wings of air,
And I do wonder:
How much more flair,
I would require
To please her?

BLESSINGS OF A GOLDEN DAWN (31)

As the new dawn arrives,
I watch with open eyed wonder
Of a new born;
Golden sun,
The colour of molten gold.

The song bird's singing throat,
Gets a golden necklace.
It's not so pretty feet,
Gets a golden anklet.
The crown-head's crown,
Is plated with pure gold.

The scattered grain
Shines like golden sand.
So many stars
Shining all at once.

The dry twigs
Are no longer poor;
They all are made
Of pure molten gold.

So much of a miracle
In an everyday affair.
The sun the painter;
Redeemer of a golden dawn,
In which everything has an aura
Of pure molten gold.

Countless are the blessings
Of a golden dawn,
Making our dreams
Pure golden.

ONE DROP OF RAIN FILLED A FLOWER BOWL! (32)

One drop - one cute drop:
One drop of rain
Filled a flower bowl.
The scene filled,
The poet's heart;
His heart, now so glad!

The same drop
Filled his ink-pot;
Flowed out
As the blessed
Enchanted word!

I always wondered:
While looking at bees,
Birds- humming birds,
And butterflies;
Did you know?
A mere rain drop,
Is the mother of
A coloured heaven
Called the flower bowl.

Flowers, you smile
In perfect harmony;
Sway and dance with
The fragrant wind,
In perfect rhythm.

For, they bless your wombs
With fertile seeds,
And blessed offspring,
Who return the smiles
For favours granted!

Nature's enchanting cycle
Stops for none,
Neither for the peasant
Nor for the poet.

One drop of rain
Filled a flower bowl;
The scene filled
The poet's heart.
His heart, now so glad!

FROM THE DEPTHS OF AN OCEAN (33)

From the depths of the vast ocean,
One wave surfaced,
Hesitated a little,
And rushed towards
The shores,
Only to find its embrace
Ending as effervescent bubbles,
Crawling, creepy crabs,
And a sigh pervading
The ocean.

You draw something on the ocean;
Does it get drawn
On the shores too?
You make me think;
And mind also becomes
An ocean,
With countless
Ceaseless waves!

EAGER FOR THE FIRST BREAK OF THE DAWN (34)

I am eager and impatient,
For the first
Break of the dawn.
The first tinge
Of crimson,
Like the rosy cheek
Of the bride:
Shy and coy,
About to enter
Her bridal chamber.

The first shaft
Of silvery light,
As it cuts
A measly cobweb,
With scythe like light
And reveals a beautiful design:
Even in a trap of death,
For the lover bees,
The beautiful butterflies.

What an object lesson:
To evade the clutches
Of evil,
For the lover bees,
For the butterflies,
As they seek the oozing elixir,
Of love -called honey.

Light -the first architect,
As he built
The citadel of light;
The fort
And the rampart,
A majestic castle,
Fit for the first king,
Kind enough
To rule the kingdom
Of light:
The effulgent and blessed heavens.

Be kind then, to send down
The chariot of light,
With hope as the rider,
And faith as the passenger.
Then it never can be an ordinary day,
With the threat
Of the rain clouds looming large,
To obstruct
Its path and passage.

HOW MUCH DO YOU LOVE THE PRINCESS? (35)

How much do you love the princess?
How much do you love princess Dawn?
This question;
I hear with the first blush-
Of the crimson Sun.

The first streak
Of light:
Silvery bright
Happy and chirpy,
As the singing bird.

She -my beloved:
An honoured guest
In the chariot of fire,
Driven by the Sun God.

Drawn by the spotless white
Seven stallions,
With bodies made of light;
Day after day,
Year after year!

As she unfurls
Her flag of hope,
And its belly
Filled by the merciful winds,
Of almighty,
I hope and pray:
May the day bring
Avenues for work;
Royal roads
To happiness
For me;
And also for my not so happy brothers.

THE SUN HAS COME OUT! (36)

The sun has come out;
Where have the dark clouds
Hidden their black robes?
They got merged
Into the core
Of its shiny delight!

It is better to bring light
To the world,
Than deny the world
Its share of light.

That was what
They learned from
The proximity with
The sun's effulgent light!

Disease and darkness;
You learn from the clouds!
Never, never
To cast your shadow,
In the path of divine light!

THEY REAPPEAR AS SMILING FLOWERS! (37)

When I see a riot of colours:
An exquisite bunch of Roses,
All colours,
Adorning my Rose gardens.

All hues of a tropical sunset;
Wafting fragrance
Filling the winds
With exquisite scent.

My neighbour's quizzical eyes
Admiring eyes, says
It all:
"What blessed sights
And scents, how could you?"

My only answer:
I make children's smiles
Bloom every day
In my path to work;
Back to home,
They reappear
As smiling flowers
In my blessed garden!

CALM AFTER THE STORM! (38)

When nature howls-
Fiendish blood curdling howls,
Banshee howls,
The whorls of destruction,
Spin, drag and pull
Man and animal,
To a web of death.

Sowing seeds
Of devastation
And destruction;
When buildings crumble
Like toy match boxes.
All life's possessions,
Hard earned after
Years of sweat and toil,
Get dissolved in sheets
Of rain.

When despair knows
No bounds;
And happiness
Has no royal roads;
Not even mud paths-
To reach your souls.

No tears left
In the eyes
For expressing loss.
We implore thee:
Never again
Such demon winds,
Should cross our backyards.

We pray to your merciful grace:
All of thee,
Oh, merciful Goddess!
Thanks, at least
Our life breaths are intact!

Far away India
Is walking up to
The breakfast table;
With a little concern,
As the breakfast news
Unwinds before a hot cup.
How lucky we are:
Not to be in the path
Of Yasi!

Let our brothers recoup
And settle things,
With a will of iron.
We will support
In whatever way we can.

THE WEEPING WILLOWS (39)

The weeping willows
Sat by the pool-side,
Never got up from there,
Ever again.

Their musings,
Their reveries,
Their sighs and despairs
Mingled with the winds,
Which whipped tiny waves
On the serene face
Of the limpid pool;
Set gentle waves
Among the colourful flowerbeds.

Everyone may wear bright clothes
And brighter, happier smiles
For the rites of the spring,
But the weeping willows
With their melancholy smiles,
Are loners in the park,
Befriended only by,
The poet and the destitute.

The park benches may see
Crawling toddlers,
Clinging to its painted hand rest.
Aged couples, anxious lovers,
All change the moods,
And the dreams
Which float in the air.

But the weeping willow stands a loner,
With a grief beyond redemption!
Maybe it is a philosopher
In the making,
To underscore the point
That the fabric of life
Is woven with one thread too many,
Of misery and misfortune.

Wish I knew its secret,
The weeping willow-
The mournful fellow:
A loner in the park,
And a philosopher-
In the making!

A LITTLE SUNSHINE (40)

A little sunshine
Everybody can give
To the world
In mourning,
When grey clouds
Shut out the sun
Make us forget that
The sun is ever shining.

A little peck
Of affection,
Can dry up-or drink up
A tear drop,
Faster than the sun.

A frown disappears
Like mist, at the
Arrival of the sun,
If a lovelorn
Look strikes the care-worn.

Merry mornings
Are here to stay,
As the sun-beam
Melts one more cobweb
In the corners
Of my old brain.

WHAT MAKES YOU BLOOM, OH, CACTUS? (41)

What makes you bloom
Oh, lowly cactus,
Eye sore of the Rose gardens,
Never the favourite of the dignitaries
Or lovers and poet's quills?

It is the soul
Which feels
The oppression
Of a thorny prison,
And dreams
Of eternal springs;
Joyous fountains,
Rivulets and ripples,
Singing happy tunes
In unison;
Of a lover's dream,
Never caged
Or tied by chains
Of a tyrant-
Called the emperor:
Destroyer of all that is beautiful,
Time!

CHILDREN

"When God wanted to see himself as he is: innocence personified, he made the perfect mirrors-Children. When Mother earth wanted to do likewise –flowers appeared"

THANK GOD FOR LITTLE GIRLS! (1)

Lovely little girls
Lovable little angels
Love filled nectar pots
Hugging bubbly parcels.

Thank God, for little girls
Wherever they are,
There is a shower of smiles.
No scowls, only doting souls!

If only they remained
As mothers of innocence,
Feeding your souls
With the milk of human kindness!

Earth would have escaped
A trail of violence.
Blood, tears and wars
And rivers of tears.

No orphans left behind to look
At the rising sun,
With love -dead eyes
And fear filled souls,
Staring blankly at
A dreadful and dreary future!

Thank God for little girls!
Wherever they are;
There is a shower of smiles.
No scowls, only doting souls!

DRAGONFLIES AND BUTTERFLIES (2)

This poem is dedicated to all children, who plagued by some serious malady, are unable to chase Dragonflies and Butterflies in the morning

Dragonflies and butterflies
Are up and early,
At work and play,
Along with the first sun beams:
Shafts of light;
Silvery cobwebs made of light!

Halos of another world
Appear and disappear,
Dancing with the swaying leaves;
A picture of exquisite delight.

Fog and light
Playing hide and seek,
Among the trees;
On the dew drenched-
Carpets of velvety green grass.

A wild flower's cup
Is full with the dewdrop.
Another big flower:
A nameless beauty
Smiles coyly,
Longing for more!

Dragonflies and Butterflies,
Part their ways
To seek their beloveds
Amongst the choicest flowers.
One has a banded tail:
Long and taut,
Like, the hunting tiger on the prowl.
The other has myriad eyes
On its petal soft wings,
Like, the peacock's enchanting plumes.

One whirs like a chopper;
The other flitters,
And soars up like the flower petals,
Cast in the winds.

Seekers of honey,
Amidst the sap filled trees.
Ecstatic beloveds of ours,
Waiting with honey filled-
Chambers dark and moist.
Nectarine elixir:
Givers of infinite joy.

We take no notice
Of the evil spiders,
Weaving mean nets
For the errant bees.
To trap us and devour us,
Or the spear like thorns:
Guarding our beloveds,
From the sand paper tongues
Of preying cattle.

We fly wild with joy,
Amongst our most precious
Beloveds forever;
At all times,
Shining with the morning's glories.

Our souls and hearts
Intent on seeking love's fresh faces,
And every morning beckons,
With new tales to tell.

Dragonflies and butterflies
Are up and early,
At work and play,
And every morning beckons,
With new tales to tell.

INNOCENCE'S BEST FACES (3)

A child runs towards you,
Because of love!
Misery runs away
From you,
Because of the child's love!

A child is lost to the world,
The day you whisper,
"Be worldly wise"
In its ears.

Never let loose
A child alone-
In the wilderness of the world;
And lose a child forever,
To the jungle,
Where predators abound!

I do not love children,
Just because they are children;
Indeed I love-
Innocence's best faces yet!
Beautiful, ageless,
And adorable!

THE DAY I MET A HAPPY CHILD! (4)

The day I met a happy child:
Chirpy child,
Happy child,
On her Birthday;
Is not that a blessed day?

As she floated,
Danced,
Swirled
On virtual dancing shoes,
I heard-
Suddenly the temple bells
Ring, and bring in
Happy notes,
Usher in happy thoughts.

Velvety gown,
Satin pink
Bright and shiny,
Was her birthday attire;
As she offered a rose bud
To the mighty Goddess.
Suddenly, a parcel of happiness
Dropped from the heavens,
Into her cute little palms.

Her face showed no wonder
And amazement.
The world is full of good people;
Uncles are always nice,
And sweet on my birthday!

Happy birthday, little Goddess!
In you, we find
Little, little wonders!
Great lessons
To learn and wonder.

AN ANGELIC SMILE (5)

An angelic smile,
Lights up the life
Of a beholder.
An angelic kiss
Shows that
Children can take us
To celestial gardens-
Shining above;
Sadly, never seen
From far below.

One hug from a child;
I never will seek again,
Love from a heart:
Stone hard
And stone-cold.

The child:
The blessed,
The caressed
God of little wonders,
And majestic mountain
Of innocence-
Shining from far.

BLESS A CHILD (6)

Bless a child!
Fresh from the mint:
An ageless mint,
Which imprints
The stamp of innocence
On the alluring face.

Smile,
Bring a shine
On the dreary day;
Laugh,
And ring in cheer
In an air
Of distrust;
Hug,
And dissolve
The alien
Among the soul-dead-
Motley crowd.

What I would do
Without you?
Humming bird-
Of yonder!
As you drink
The nectar
Of my soul,
Humming the tune-
Of love beyond,
The human and the divine!

I TALK WITH A LITTLE ICON OF LOVE! (7)

I talk with
A little girl:
A little icon
Of great love.

"Little girls
Are made of sugar
And spice!"
Have you heard that?
She blushes,
Answers with a winsome smile,
Which broadens,
As a chocolate changes
Hands –now held by little palms.

She has not
Heard that;
For she is still in her
Preppie school.
But she has understood
What a little gesture;
A sweet little peck-
On her pretty cheeks
Means, and means a lot!

A BUNDLE OF JOY! (8)

A bundle of joy:
A bundle of innocence
Wrapped in divine love.
A gift from the heavens:
Shows us the stuff which fills
The heavens,
With her winsome smiles!

I do not believe
That a stork brought you
To my neighbour's doorstep;
Rather, an angel brought you,
In a parcel of grace,
Personified, deified and glorified.

May the God- mother's kisses
Always warm you,
Nourish you,
So that when your return
Back to your divine abode,
You might have taught us,
Mean earthlings,
A thing or two about
Divine love:
Mother's love.

ODE TO A SWEET NIECE (9)

You have been
Sent by heaven,
With a divine
Sweet face:
An alluring face,
Full of heavenly charm and grace.

In this world of make -believe,
I have known your love
To be real,
And cent percent soul.

How, you dance!
Like as if you can enter
Into a contest
With the wind,
Weave the magic wand,
And win with your hands down
In the end.

Your nimble footed dance:
It will shame,
Even the male peacock-
The maestro -and make him strut!
Make him wince,
And in the end lose!

Win always
Oh, sweet flower-
Of fine art.
May laurels shower and heap,
One after another,
As you begin on a glorious career.

ARCHANA'S BIRTHDAY (10)

Dedicated to my little Goddess Archana on Her Birthday

Let this day be the longest,
Happy tunes
Last a whole year,
Mummy's smile as she wakes
And whispers "***HAPPY BIRTH DAY***"
Waking me to begin -
The happiest day,
The brightest.

Papa is full of surprises:
As he holds back his surprise gift-
And smiles with mischief:
What an angelic dress!
Velvet white and flowing
Complete with-
Fairy's wings,
Magic wand and hair band.

Today I want to
Fly like a fairy,
Dance like a Cinderella,
And fly through the-
Cotton white, fluffy clouds.
With my friends, just floating
Fun, frolic and mirth our buddies!

May this day never end!
The shower of gifts never stop!
And smiling faces-
Bloom like flowers,
And I will party-
Till I drop down,
To a heavenly soft pillow!

CHILDREN, CHILDREN EVERY WHERE! (11)

Children, children everywhere;
Not a smile
To be seen anywhere.

Wall street
Parliament street
Gateway of India
Did you see those flowers wilt
In a corner of the street?
As they slept-
On the side walk;
Through dreamless joyless sleep,
With the friendly Samaritan:
The stray mongrel of the street,
Keeping a loyal guard.

One can fly to Mars,
Or spend a life time,
Planning grand trips
For the rich and the famous;
But to make the food reach
Bottomless pits
Called rumbling stomachs,
All the plans we need,
Are only simple ones
Coming straight from the heart.

Come Happy Diwali!
Come Happy Xmas!
Come Happy New year!
You are most welcome to our poor street!

For, at least one day in our sordid life,
Let there be some sunshine-
And a bubble of joy!
There, being no dearth
Of good Samaritans,
And holy devotees
On such a happy day.

Some stray thoughts, after knowing about the street children of all the countries: yours, mine and others.

MY SWEET, LITTLE GODDESS, JOSEPHINE! (12)

This poem is dedicated to sweet, little Goddess, Josephine- who is Marcia's little grand daughter who turned 3 the other day.

Smile, oh, little Goddess!
Cuddly, cherubic little angel,
Knows the world very little,
Yet, smiles a great deal!

Golden haired
Serene sky-blue eyed,
Cute little doll!

Hugs and kisses,
From the land of kings(maharajas),
Snake charmers,
Magicians and conjurers,
Rope-trick fellows,
Tame elephants,
Bullock carts and Mercedes.

Big tailed monkeys
Furry long-tailed squirrels-
Tame and eating out of hands,
Hunch backed camels
Tame tigers,
Yawning, and sleeping like cats!

What fun it would have been,
To enjoy the elephant ride;
To see it, and laugh aloud,
To keep your eyes wide open-
In wonder and great fun!

Love you, little darling!
Happy birthday, Josephine!

HOMAGE TO COURAGE

"Brave men are born in the battle field. Thereafter, they live forever in people's hearts and lives, and their tales inspire folk lore."

MICE AND MEN (1)

Of mice and men,
We have seen plenty.
But of really brave men,
We are not so lucky.

The sun rises only to set;
Brave man rises,
Only to see that
Virtue never sets.

His words echo in lore
And fairy tales,
His deeds are carved in
Letters of gold.

But his soul
Defies description:
For, it is all pervading,
Like the omniscient Lord!

In God, he lives.
God is only too happy,
To give him a place
In his bosom.

He has a face,
Which is as old
As the mountains.
Raiders come and go,
But, true to their nature,
Both do not bow their heads.

This is the truth
As old as the mountains:
Mountains and heroes,
Both do not ever
Bow their heads,
Before wicked deeds
And blackened souls.

LIVE AND LET LIVE! (2)

"Live and Let Live"
Late Ms. Sarojini Naidu- Poetess and Freedom Fighter!

Live and let live!
Foster and rear,
The power to live and let live!

Let new India arise!
Not by sounding clarion calls
Or by leading invading armies,
But holding her head high,
And flying the flag high:
A flag of values.
Lofty values,
Which separate the mighty
From the lofty,
And making the life
On this planet,
Worthy of living!

Alas! her own children
Have flouted these very own
Values, time and again,
And imprisoned their own
Kith and kin,
In moth-eaten traditions,
And raw-corruption
Wrapped neatly in tradition.

This cannot go on,
Go on, and on!
Time to march on.
Open the flood gates
Of liberation,
Holding the torch of science,
Donning the garb of fearlessness.

Together, we will regain
The lost glory
Of our ancient land,
Where the lamp of wisdom
Burned serenely,
Attracting all seekers
Of illumination -
From deep within!

HUNGER RAISES ANGER! (3)

Hunger raises anger,
Indignant anger,
When you know it
For sure:
That it is man-made.

Bountiful nature
Raises crops,
Blesses the farms;
Rich harvests pile and heap.

But the mall -sharks
Thriving on lands,
Want to raise their
Profit piles of coins,
Even higher, to touch the skies.

Result: food grains
Rotting in clandestine
Barns and Go-downs,
As gleeful hoarders
Descend en masse to swoop
On the ripe moment,
Their hawk eyes
Missing no opportunity.

The fire of hunger
Is no longer
Confined to a pit
Of the stomach,
But becomes a conflagration,
Burning all human values
In its fiery path.

Awaken the poor,
To stand up and fight
For the right for food,
And dignity of the human.
Now, or it will be never!

One out of every six humans has nothing to eat(That makes it more than one billion!) We should also join the world wide movement against hunger. Be a signatory to this great cause and pool public opinion to twist the arm of the wicked and uncaring politician. We sure can do it, with the might of the ballot resting with us!

WHEN THE WORLD IS BURNING (4)

"When the world is burning with so much misery, how can you sleep?"
Swami Vivekananda

When the world
Is burning with
So much misery,
How can you sleep?

You may have flower beds
And ornate bed-stands,
That does not assure you sleep,
Comfortable and restful sleep.

The night is young
And coy like a bride.
There are many young,
Who are prematurely old,
Poor and famished;
Cause, no morsel of food
Has gone into their mouths,
For days and nights.

How to starve under
A mighty skyscraper,
People know this.
Destiny has taught this;
Economy touching the skies,
Ruled by powerful politicians
Know not their-
Tale of woes.

Free the slaves
Of the millennium.
Cut asunder their bonds
Forged by the cruel years.

My pen becomes your sword,
Oh, great Goddess!
When I wield it
To fight injustice.

Want it to strike
At the roots
Of misery,
In an existence so dreary.

The Goddess of justice and compassion
Has spoken
In the still of the night,
A dark and long night:
Stormy and dreamless night.

The night is still young
And coy like a bride,
For the ones
Who are out on a joy ride.

But for me, it is
Time to awaken
And sound the clarion call-
For yet another battle:
Bloody and fierce battle.

By her grace,
Pen will become
Mightier than a sword.
And an empire of evil
Will be brought down.

A GRAVE WHISPERS! (5)

Warriors are born
In battlefields;
Generals are made
In staff colleges.

Remember this, and jump
Headlong into the battlefield.

Remember the valorous queen Lakshmi *
Of Jhansi
And her last prayer
In the dying moments:
"Oh mother India, mother Durga!*
I could not fulfil the task
Assigned to me.
I could not break the mother's chains
And see the dawn
Of freedom.

Grant me one more birth!
I will return
With gratitude,
To fulfil your wish!"

Be worthy of her great sacrifice.
Her grave whispers
Life giving mantra:
"Be a worthy son
Of our mother.
Be lions
Of determination!

Jackals may be large in number;
They can never hunt down
A lion's kin!"

The second war
Of independence
Has begun.
Join and win!
Watch the smiles
Of the flowers,
As they bloom in thousands
On her grave,
Coloured blood red
By her sacrificial blood.

*A tribute and eulogy to the great Queen Of Jhansi who
sacrificed her offspring's and her life in the battlefield, in the
first war of independence against the British in 1857.

A LEADER IS BORN (6)

In a country
Full of strife
And grief,
One sane man
Stands up for other men:
Fallen men,
Down-trodden men.

Desperate men
Deprived men
Desolate men,
Lost and drifting men.

He is like no other man,
Heard or seen.
He is born then,
To tell them,
To stand erect,
To stand upright,
To fight for their right!

To stand on their feet:
Hard working- toiling feet,
And never to accept
Kicks from tyranny's oppressive feet.

If at all they do,
Then severe it,
With one blow of their hatchet
Without any thought
About it;
By God, no thought about it.

A leader is born this very moment,
Our very own blessed moment.
A new twist
To the old battle,
Against tyranny
And penury;
The inheritance of
The ever toiling
Pairs of feet!

RISE! OH, MOTHER INDIA! (7)

Rise, oh, mother India!
Awaken your sleeping children,
Ungrateful children
Who sold your values,
Your honour,
Your ornaments
Of the finest human
Virtues and teachings,
For a few coins,
Scattered by the invading enemies.

Scheming traders
Became your rulers;
Sly foxes calling themselves-
Conquerors.

This has been your sad plight
Through the ages,
Aeons and many lingering, painful
Miserable years.

Time to change all that.
Wield your axes,
Break her chains,
Evict the villains
Who masquerade
As leaders.

Self -serving politicians
Who drain the nation's treasury;
Cause of penury
For the teeming millions,
Who go to bed
On empty stomachs;
Fill it with empty promises,
Hot air and baloney.

Time for a change!
It is now or never.
Onward march!
Time waits for none:
Not for the loafer
And the looter,
Nor for the philosopher.

Be the driver
Of change;
A change for the better.
Better country,
Without bitter citizens.

THE SLEEPING WARRIER (8)

When you awaken
The sleeping warrior within,
Life's peace is best felt
In the battlefield,
Among booming guns,
Scowling faces,
Angry chattering teeth
And flesh eating jackals
Scrounging carcasses.

He is ever battle ready
Like the great Goddess,
Ready to tear the wicked to shreds,
Drink up the last drops
Of their black blood,
Made blacker by dark deeds.

What is there in life?
If, at least for once;
One has not wielded the battle axe
And split a wicked armour.
Broken through the dark chambers
Of a demonic heart,
And emptied its blood
On the parched and furrowed lips
Of a thirsty mother-earth.

HOMAGE TO COURAGE! (9)

This is a homage to two real- life heroes who, while displaying their skills in formation flying met with an accident during a recent international air show at Hyderabad airport in India, a few days ago. While they could have pressed the ejection buttons and bailed out to safety, they chose deliberately to welcome a hero's death, and guided their burning plane to a lone roof top water tank. They both paid the supreme sacrifice, and saved scores of spectators, who just did not realize immediately what happened, as there was no major fire; only a single flat occupant's life was lost! Today, when I looked out through my window panes in the morning, I saw the smoke trails of two jets crisscrossing the skies, with two shiny silver crosses of planes at its apexes, symbolizing the ascent to heavens of these two noble souls. May God grant them eternal life in the spotless heavens meant for brave hearts!

Courage, do you ever lament
When you lose two of your
Brave and noble sons?
What did you feed them
Along with their mother's milk?

I never heard a fable
Of flying lions,
No mythology has foretold,
Such an amazing tale!

Nobility, you are
Sacrifice's twin sister,
Together you clothed
Their sacred remains,
In immortality's veil!

Destiny's children:
Both of you!
Together you will play
In the celestial gardens,
Flying gilded paper planes,
Shrieking all the way,
And watching in amazement:
Cause nothing perishes
In these Eden gardens,
Neither man nor metal!

REVOLUTION BEGINS WITH A TEAR DROP (10)

Every revolution
Begins with a tear drop
Before anger rises
And erupts;
Like the smouldering heap
Suddenly becomes
A raging volcano.

When hunger
Grows by the hour,
What to talk about
Economy growing
Faster by the year?

Today night
As good as yesterday night;
As I sleep it out
With nothing left
To burn in a pit
Called the slum-dweller's stomach.

Even Gandhi
Would have thrown overboard
His 'Ahimsa'* creed
And gladly knifed
The demon horde
Who hold
The power to create more slums,
To fill empty tummies
With election promises.

Arise, awake!
Wake up,
Oh, fellow brothers
And soul sisters!
Before our rivers sacred,
Are coloured
With the blood
Of innocents.

You cannot let corruption
Win a lasting win.
The Goddess of battle
Will sharpen
Your axe and weapon.
Onward march,
And sound the battle clarion!

Mother India has been in chains:
Forged by corruption,
Moulded in tradition.
Wield the battle axe
And break her chains-
Of long and dreadful
Years of slavery!

*Ahimsa means non violence

CALL TO BATTLE STATIONS (11)

Get to work!
More work!
This is a call-
To battle stations.

Ready your guns!
Get your enemies-
In the sights
Of the guns.
Ready, aim! fire!

Let the guns
Spit fire and spew destruction's
Acrid and pungent smoke.
Enormous columns,
Hanging like black -death.

Let us spread death-beds
On the ocean waves,
For the enemy,
And his armada.

Cease not, stop not!
Till the last of his mean ships
Sinks down to the bottom's
Dark depths,
Cold and dark.
Fathomless depths-
Alien to light and life!

WHEN YOUR SHIP IS ON FIRE! (12)

When your ship
Is on fire,
On the high seas;
Never jump overboard.

That is left to the
Rats - smelly rats.
Water is plenty
Buckets are plenty.

Many strong hands
On board.
Put out the fire,
Before it destroys
Your only refuge.

It is a shame
To lose
The ship on the high seas,
When you have set sail
On a voyage to discovery,
To discover your Eden.
Your promised land;
Your future homeland.

HAIL MOTHER INDIA! (13)

Hail mother India!
None like you,
In the whole world.

Your soul ever so pure,
And a seeker of light.
Teacher of the path
And the glory of eternal light:
Divine and leading light.

You are a land of stark contrasts,
The Mercedes limousine,
Sharing the road-
With a rickety bullock cart.

You are a technological marvel,
Among the superpowers:
Who can land a craft
On the moon,
But many of your villages-
Have not heard about Edison,
Or seen his magic electric bulb.

You produce enough food
To feed a country-
Of twice your population;
Yet millions go to bed-
Without a morsel
Of food at night.

Yet, you are unique
And a glorious mother.
Problems mountainous:
Size enormous,
But your children do not believe
In blood bath and rivers of blood,
To drown your problems.

Arise! awake!
Wake up your sleeping children.
Make them shed the dirty,
Clothes stained and soggy
With corruption.
Let them swim with the current
Of action and selfless service,
To their brothers and their motherland.

Hail the divine mother! Hail mother India!

Oh, DARE DEVIL (14)

Oh, dare devil!
Why are you never afraid
Of a fall?
From a steep precipice,
Or a mighty rock cliff!

The valley of death,
Awaits with mouth-
Agape and wide open.
You never cast
As much as
A fleeting glance,
In your pursuit
Of the summit.

Brave men
Follow you;
Adore you.
The years sing your praise
Through folk lore.
You remain
The death defying spirit.

Oh, dare devil!
You are our sedate life's
Thrill and soul,
To soak up and smile!

FESTIVAL

"One never ending day of song and dance on earth. I will gladly trade many years of heaven for such a festival day"

DELIGHT IN THE AIR - ONAM FESTIVAL (1)

Poetry stems from the heart,
Aims for the heart,
Blooms best,
When love is in the air.

Plucks at your heart strings,
Divine music floats,
Enchantment pours.
Flood of emotions,
Enter all the chambers
Of the quivering
Throbbing heart.
Still there is room-
For more!

There is delight in the air,
Flushes on faces,
With excitement and joy.
People donning,
Bright and white
Rich and ornate,
Festival clothes.

Caparisoned elephants
Lead the way,
Floral carpets and circles
Smile all the way,
Snake boat races,
Cheering crowds
Running on the shores,
To egg their favourites
To win races,
All adorn the landscape.

Lamps burn bright,
A million glowing wicks.
Ladies with floral bands
On their heads,
Dressed up like coy brides,
Perform the ritual dances,
Going round in circles,
A divine sight
Fit for the Gods.

The farmers' granaries
Are full and overflowing;
So are their hearts.
Nature is washed clean.
Green carpets welcome;
Flowers smile
From every nook and corner!

The scene is set
For the royal descent,
Equality -fraternity,
Love, truth and delight
They all dance together with joy.
Our king is here,
At least for the day.
Delight is in the air;
Beyond words and songs!

ONAM - is the most important festival for all Keralites, who hail from Kerala, a state forming the southern- most tip of India. This event celebrates the home coming of its former illustrious ruler -King Mahabali- once in an year. The Legend says that during his reign, all subjects were equal and love remained supreme; false hood -even the size of a mustard seed- was never seen. It is sheer delight to visit Kerala during ONAM. No strangers, only honoured guests, as the many foreign tourists who visit Kerala during this time will vouch for!

A WHITE CHRISTMAS (2)

Icicles grow many fingers,
Hang like ornate chandeliers,
Trees are snow white;
They have learnt to smile-
Without a single flower,
Anywhere and everywhere.

Purity is everywhere,
Pristine pure
And snow white
Virgin snow,
Has spread its carpet
Everywhere!

Streets, lamp posts
Alleys and corners
All don virgin white,
Like the coy bride,
Looking for the happiest day,
Unfolding slowly.

Are not people
Too happy to glide down?
Smoothly and gleefully,
To the valleys of mirth,
Fun and frolic!

Children can barely wait!
As they lie awake
Feigning sleep,
Pricking their ears
For Santa's sleigh bells
And his footsteps;
Their souls agog,
With thrill and excitement.
What will he bring this time around?
In woolly white socks
And his bag of goodies!

Xmas is here,
Every face is wrapped in smiles!
Every one hums
Happy tunes,
Every soul is full to the brim
With hope and cheer,
Run away, blues!
And hide behind the dark clouds!

It is Xmas morn,
And I lay a table,
Full of goodies filled
With chocolate and cream,
And love for my kids,
Tenderly and lovingly!

HAPPY ANNIVERSARY MOTHER INDIA! (3)

There is none quite like you
In the whole world,
Oh! fond mother,
Mother India:
You are our most beloved mother!

May you emerge out of the shadows
May your power grow out of bounds;
Not through the booming, sinister guns
Or marauding armies,
Or screeching shiny grey metal birds:
Evil faced war-planes;
Shrieking banshees-
Sowing seeds of destruction;
The enormous mushroom clouds
Rising, and turning the serene skies
Into blood-soaked shrouds.

Gleefully evaporating lives,
Dreams, hopes and fond memories,
Burning the angelic peace's
Spotless white clothes!

You will remain eternal and vibrant:
Abode of eternal values,
Which rocked the cradle-
Of civilization;
As the new born baby
Learned to walk the first,
Tottering, gingerly steps
In the path of knowledge.

Greetings, oh, fond mother!
Ungrateful children have
Robbed you, of your shiny ornaments,
Yet, you remain beautiful,
Eternally and forever;
For, there never is an ugly mother
For a devout child!

Arise and awake,
Never to stop till
The goal is achieved.
Come out of the shadows,
Till you take your rightful place:
A pride of place,
Among the prime nations,
As you did- once before!

Tail piece: A.L. Basham once wrote an epic book on India-

"The wonder that was India". I would add: "Mother India -You will never cease to be a wonder!"

HOURS TO GO FOR X'MAS (4)

Hours to go for Xmas!
Why they hang like dead-weight?
Has time stopped its flow?

Ask your Reindeer to run,
And outrun
Each-other.
Little John and pretty Lisa
Want to see:
The socks bursting at seams!

All night we lay
Under a starry sky,
Feigning sleep.
Our hearts and minds agog,
With hope and dreams,
And hidden excitement:
What will Santa bring,
This time-around?
When will it end?

Uncle Santa, please, please!
Why can't you make haste?

THE STAR HAS RISEN! (5)

The star has risen:
The star of Bethlehem!
Hopes and faith,
Will be born,
In the Xmas morn.

Wake up little John!
Liza, Maria and Kohn
Greet the new born!
How alluring
How charming.
How loving,
Is the adoring
Mother and child:
Madonna so sweet and serene!

Love was not born yesterday;
But its glory will be seen today:
As bells jingle,
Crackers burst,
Heralding the divine descent.

Icing smiles with a frothy smile,
On a cherry eyed cake;
Happiness is
A freshly baked cake;
Waiting on the table,
Like a coy bride.
Ready to be eaten
And merge in you!

WHEN YOU WELCOME THE XMAS MORN (6)

When you welcome
The merry Xmas morn;
Beware of the dark demon
Of depression,
Lurking behind the corner.

Subtle and wily,
He is ever ready
To see loss and want.
A gift, less thought of;
A lack of spontaneity
In appreciation;
And he begins his reign.

Home sweet home
Will have gloom;
A pall of gloom,
Suddenly descending
And thickening
The joyous sky;
Like the oppressed earth,
Under an overcast grey-
Mournful sky.

We shall overcome
The demon and his wile,
And brighten our home.
Greet our neighbour
With warmth and glow;
And usher in
The Xmas morn,
Alluring and unforgettable.

Merry Xmas! Be grateful to God for blessings galore!

SANTA RIDES A HAPPY WAVE! (7)

Santa atop
A Xmas tree;
And the song begins
On a happy note!

Merry Xmas:
Gleeful smiles
Naughty pranks
Stockings holding surprises
Gifts and blessings
Mesmerizing toys.

Hugs and kisses
Cakes, ales and roses
Blood red wine flows
Turkey, lamb and beef roasts.
Tummy fills
Till it aches;
Till it matches
Uncle Santa Claus's.

Santa atop a tree:
My beautiful Xmas tree.
Happy atop the tree:
The adorable tree.

He, riding the crest
Of a happy wave.
Flooding all corners
And shores,
Of a happy home:
Sweet Xmas home,
With frothy bubbles
Of chirpy happiness!

MERRY XMAS AS SANTA'S SLEIGH BELLS ARE HEARD!.

HAPPY HOLI! (8)

Holi has arrived,
Sprinkled anew:
A riot of colours
All at once!

Every face wears
A mask of colour.
For young and old alike;
Happy days are here again.

People who lived
Drab lives:
Who forgot to smile,
Wear now sunny smiles;
Are vibrant with colours
So bright and radiant-
As vibrant as life.

Recharged with
Renewed vigour;
And zest for a colourful life,
At least, for today!

Today is the festival of HOLI- where friends attack each other with water pistols, syringes, smear colour on each other; get soaked to the skin with coloured water, and cast the veils of age and inhibition by the wayside! A delightful festival - vibrant with life- and eagerly looked forward to, by young and old alike!

EPILOGUE

This last poem is dedicated to the sacred memory of my late father Dr. Damodar Prasad, from whom I inherited a wee bit of the poetical mind.

LIKE FATHER -LIKE SON

Like father -like son,
Says ancient men;
Of great wisdom-
And ever flowing pen.

Like father,
Son quite unlike father,
Not exactly a chip-
Of the old block.

Father and son:
Both misfits,
In a go-getting world
Perfect round pegs
In square holes,
Cherished and chased values
In a shadow world,
Weary of values.

Father dug a grave of ambitions,
Buried his dreams and ambitions,
Sought the kinship of letters,
And the worn quills -
Of famished poets.

The son struggled to dig -
Deep for some home truths,
Not for gold and diamonds,
Truths which the world calls as
The science of the ephemeral-
Phenomenal world.

Father gave the son-
An invaluable lesson,
"Be a stone-breaker,
Toil in the sun,
For salt and bread,
Cast never even a shadow of grief,
In others life;
Or break even a single heart,
Even in jest,
Or for fun"

Dedicated to the event - 30'th death anniversary Of late Dr.Damodar Prasad - Professor of Hindi Literature and disciple of late Dr.Nanda Dulari Vajpayee, an eminent literary figure of India.

My father never craved for money or fame, but wrote sublime and soulful poetry and was a vastly underrated poet in Hindi language(The National Language of India), which was not his mother tongue! This ode is dedicated to his sacred memory.

Printed in the United States
By Bookmasters